Modern
and Primitive Art

Charles Wentinck

Modern and Primitive Art

Phaidon · Oxford

Acknowledgements

The author of this book is a specialist on primitive and modern art. The 1972 exhibition at Olympia 'World civilizations and modern art' provided him with the opportunity to finish his book. With the help of Prof. Dr. Siegfried Wichmann and Dr. Manfred Schneckenburger, who selected the pictures for the exhibition, it was possible to enlarge the illustrated section of the book. Dr. Schneckenburger, in particular, who organized the sections on Africa, the South Sea Islands and Indo-America for the Munich exhibition, showed a great willingness to help. I owe the completion of this book, as regards the illustrations, to him. I also owe him great thanks for his contribution to my theme through his organisation of the exhibition. I am very grateful to Otto Bihalji-Merin, Carola Giedeon-Welcker and Jean Laude for their publications and advice.

Photographic acknowledgements

Unspecified photographs are from the archives of the publishers and the author. Numbers without a page reference refer to the numbers of the colour plates.

Helmuth Nils Loose: 1a, 1b, 3a, 3b, 4b, 5a, 5b, 6a, 6b, 7a, 8a, 8b, 10a, 10b, 11a, 12a, 14a, 14b, 19a, 19b, 21b, 22a, 22b, 23a, 24b, 25b, 26a, 26b, 27b, 28a, 29a, 29b, 30a, 31a, 33a, 33b, 34a, 35a, 35b, 39a,
Photothèque, Paris: 2a, 2b, 12b, 19b, 23b, 27a, 30b,
Claus and Liselotte Hansmann: Cover, 4a, 9a, 11b, 16a, 32a, 32b, 34b.
Philadelphia Museum of Art: 9b.

Translated by Hilary Davies

Phaidon Press Limited, Littlegate House, St Ebbe's Street, Oxford
Published in the United States of America by E. P. Dutton, New York
First published in Great Britain 1979
Originally published as *Moderne und primitive Kunst*
1974 by Smeets Offset BV, Weert, The Netherlands
German text © 1974 by Verlag Herder KG, Freiburg im Breisgau
Illustrations © Beeldrecht, Amsterdam
English translation © 1978 by Phaidon Press Limited
ISBN 0 7148 1957 3
Library of Congress Catalog Card Number: 78-74423
Printed in The Netherlands by Smeets Offset BV, Weert

Foreword

In the chapters that follow I intend to treat the theme of the relationship between modern and primitive art with deliberate reserve and caution. The reason for this is clear. There is no fundamental relationship between the art of the 20th century and that of the so-called primitives.

Greece, the guiding light in European history, was the inspiration of the Renaissance in the 15th century. Values which had previously held good right round the Mediterranean were rediscovered. But the conditions which prevailed at the time of the birth of Greek art were not the same as those of 15th-century Italy. Nevertheless this encounter with Greek art – which was paralleled by the new life given to ancient writers by the humanists – was of lasting significance: Europe owes the evolution of its image of man, which played no decisive role in primitive art, to the influence of Greek art on the masters of the Renaissance.

In contemporary Europe, primitive art is not just exoticism but also a rich mine of forms for an age in which originality threatens to become extinct and which therefore seeks spontaneity wherever it appears. This quest by European artists for originality in the art of the South Sea Islands, Africa and other civilizations border on aesthetic exploitation. Such foreign exploitation and influences had already largely destroyed primitive civilizations. Their art cannot be used as a model: it cannot be copied, and where imitation occurs it is based on a misconception. At best, primitive art can be a touchstone. But when it is used as a criterion, it leads to judgements that are ambivalent for modern art.

It is not possible to claim that the Western world lacks expressive impulses or some 'savageness' presupposed in primitive art, for the latter is neither savage nor barbaric. 'Negro' art has its own classicism. It expresses man's existence, the complete individual, the stability of his life. It does not express the colossal, nor what is larger than life, but rather the humility which the Greeks called 'Tapeinotes' and the Romans 'Humilitas' – weakness, lowliness – that which binds human destiny to the earth' (P. M'Veng).

Nevertheless, this primitive classicism does contain a driving force, which could be called barbaric and which is searching for form and elucidation, striving for classical expression. In contemporary Europe, which no longer possesses this energy, we look for the primitive: hence there is an evident preference for archaic forms. Perhaps that is a clear indication of artistic sterility.

The tension which alone can produce a great classical form is patently lacking. The artists of the Expressionist movement tried to suggest this tension by means of distortion. Worringer has described these efforts as the pitiful philosophy of the 'as if': primitive sculpture is not art in our sense of the word because the plastic or decorative product is not separated from other manifestations of life. Art was one form of social expression amongst others, born of man's knowledge of his community, and of his religious experience. Since the Gothic age it has no longer held this function in Europe.

There is, therefore, no real inner connection between contemporary and primitive art. Where an evident affinity exists, it is often no more than an almost tragic nostalgia for the primitive world. Many modern artists are no doubt trying to salvage something of the magic nature of primitive art for contemporary Europe, although in the process the character of this magic must change. But usually the imitation of primitive art is merely a fashion.

Charles Wentinck

Dialogue with the past – return to the Elemental

The rediscovery of primitive art has been compared to the rediscovery of the ancient world during the Renaissance. Artists were suddenly seized with enthusiasm for art forms which had gone unnoticed for centuries and their works bore the stamp of this new inspiration. This had such an influence on modern artists that to imitate the primitives was seen as admissible: the artists of the Renaissance had also permitted this. But the art of the ancient world was, for the Italians, part of their own past: they turned to it to rediscover themselves. On the contrary, one has the impression that the modern discovery of primitive art is an encounter with a completely alien world. It seems that 20th-century art has no common origin with the painting and sculpture of the African negroes and the South Sea Islanders.

However, one is forced to ask whether the interest aroused by primitive art is not based on something quite different from a mere taste for the exotic; for it is not just the art of these primitive peoples which has suddenly become topical; we have come to realize, at the same time, that drawings by children and the mentally ill also represent a form of art.

European artists and critics began gradually to revalue their own past. Painters like Paolo Uccello, misunderstood by the 19th century because they were apparently too 'primitive', took the place of classical artists such as Raphael. The works of Greek sculptors, which had long been considered classical – like the frieze in the Parthenon – forfeited their popularity to the productions of more ancient times. The first book devoted to archaic Hellenic art, by Count Uexküll-Gyllenband, appeared at the same time and in the same collection as that by Carl Einstein, one of the first books on African sculpture.

This evolution continued. Very soon it was no longer archaic art which impressed modern artists, but rather the beginnings of Greek art in general. The art of the Cycladic Islands followed closely upon the discovery of the representations of gods in Thessaly. From then on the number of vanished cultures, now rediscovered, grew continually. The art of Sumeria and Assur, of Persia, the Parthians and the Sassanians appeared in 'L'univers des formes', which had never yet known such a widening of horizons. The art world, which a cultured man could have surveyed in one glance in 1900, increased its size every decade during the next sixty years. Works from prehistoric Japanese art were included; in Africa, archaeologists were bringing to light civilizations which had been entirely forgotten; the age of prehistoric frescoes was now being rated amongst the great eras of painting.

Although the volume and number of the excavations and discoveries was a little bewildering, the fact that they were pursued shows that these explorers were all motivated by the same impulse.

This world-wide phenomenon cannot be explained merely as simple scholastic curiosity. A particular nostalgia induces contemporary man to invent his past and to control it. It may be that the uncertainty of his future compels him to seek security in the past. But such a flight back in time does not adequately explain why this love for primitive forms should inspire the creative individuals of our age. It has been supposed that the difficult existence of modern man forced him to evolve simplicity of form if he wanted to express his image of the world. But such an explanation only scratches the surface of the problem.

Today, art plays quite a different role than in the 19th century. Artists are attempting to recreate a sacred element, an absolute; the sort however, that they found not in the bewitching beauty of the human form, as in Raphael, but rather in works created from a very primitive experience of God. It would no doubt be more correct to speak of 'daemonism', although this term could also lead to confusion.

Be that as it may, a new element has been introduced into European art since Goya; Malraux called it 'le démoniaque'. From that moment on an underground dialogue has been going on with the past. The violent power of the spirits of another age was unleashed. Forces, which had long been considered subdued or at least exhausted, broke loose in the political arena, while art displayed features reminiscent of the idols of the most remote peoples. The mysterious side of human nature, or rather its dark side, found expression, and so was given official recognition. The artist of the 20th century turned towards the abyss and found self knowledge in the forms of an art which revealed these depths. The art he created was caught up in a revolution which seemed to break with earlier ages and with a tradition moulded by Christian humanism. Admittedly, the art of children and the mentally ill belongs to a sphere quite distinct from primitive art. But for Klee and the artist of the Cobra group these works could play a part because in them the forces of the unconscious were contained and primary elements could show through, as is the case in some primitive artists. What could justifiably be called this century's madness has caused many things, which had practically nothing in common, to be lumped together. The unconscious and the subconscious, primitivism and naiveté, mental retardation and mental disturbance, intuition and intoxication: these words were considered to be synonyms, or at least part of a whole. This confusion often gave rise to all too hasty and erroneous conclusions. Whereas someone believed that dreams were sufficient to re-animate the imaginings of our innermost souls – by means of an automatic process, which would suddenly manifest itself – somebody else believed that every individual partook of a collective unconscious, which made him able, as it were, to create mythological forms akin to the cosmography of great civilizations. For a while it was supposed that primitive artists produced their work in a state of trance. But eventually superior knowledge proved that the negroes wrought their art with great sobriety.

Obviously it is in a certain sense only that we can claim that the modern artist encountered primitive art by chance. Art is merely the expression of an experience which suffuses all spheres of the mind. Nearly everywhere 20th-century man tries to prove that the barrenness of our civilization can only be escaped by a return to a more natural state. Rousseau, in France, began to think along these lines. Gauguin, too, turned his back on civilization by going to the South Sea Islands. Several German painters soon followed him, for, in Germany as well, the dissatisfaction with civilization had its roots in the 19th century. Nietzsche was the first to reject reason, which he considered sterile. This trend towards irrationalism evolved through Dilthey, Simmel, Scheler and Heidegger to Ludwig Klages. In his major work Klages tries to show, in a magnificent analysis of the mind, how it is the true enemy of the soul.

The great question, and the subject of this book is: what, in the final analysis, are the links between primitive art and the intellectual developments which have occurred in 20th-century Europe, as we have just sketched out? The western world was trying to find the primal experience, the sphere of the miraculous, the foundation of all things. On its way it encountered primitive art. A shock was the result, a shock of recognition. The imagination of the west was kindled by the bizarre works of these primitive forerunners, and from 1907 on an undeniable affinity of form emerged. Yet how were the sophisticated methods of expression, employed by Impressionism, to depict these elemental forces adequately? How could an art which was the product of a hopelessly isolated individual be valid for a whole society? Surely it could only be superficial? Would it not have to satisfy itself with the philosophy of the 'As-if', to use Worringer's expression? Was there not some authentic primitive force behind these works hinting at the primitive? It could be that this escape from civilization, this return to childhood, to the pre-conscious and the subconscious, to the primeval, arises more from

nostalgia than necessity. What the artist is looking for, a natural spirituality which is instinctive, close to its origins, and truly primitive, an elemental vision and a magic present, none of this is there naturally. It is for this reason that we search for it so passionately.

But this means that the assimilation of primitive art by the moderns is a belated form of romanticism. Man no longer experiences the reality of things or of himself. This also explains the emergence of abstract art.

The rational mind is glad to be freed from the mysterious forces in life, or rather, it regards this liberation as necessary and progressive. The contrasting movement, Romanticism, felt an overwhelming nostalgia for a new and more secure reality. It was born of an awareness of the disharmony between mind and body, from a split between the intellectual and the instinctive spheres of life.

The transports of Romanticism, which were the product of disappointment, may have been able to rediscover vital energies, but their origins were in conscious awareness. Creative ecstasy, on the other hand, springs from hidden depths; it imposes itself; it is a super-abundance of the self which only asks to unburden and to display itself.

But would this attempt to return to our origins not lead simply to another complacent move towards sophistication? And is there not some deep relationship between primitive art, the most powerful voice of metaphysical forces, and modern art, which prouces objects for exhibition, objects which are only evaluated from an aesthetic viewpoint? Would 20th-century primitivism not lead in the end to a white canvas, to a stone in the shape of a mere stone, to music in the form of mere noise?

The Search for the Primitive

In France, the encounter with the primitive art occurred in the Cubist and Fauve circles. What attracted Derain, Vlaminck, Matisse, Braque and Picasso above all in African sculpture was the simplicity of its shapes, the lack of anecdotal statement, the presence of magic – all things which these artists were trying to realize in their own works. Cézanne was responsible for their first introduction to primitive art. He had proclaimed that it was necessary to break down nature into simple shapes in order to create a pictorial structure. A painting is a conscious construction originating in simplified forms borrowed from nature; it is not a copy of this nature. This was the point where Western and African art coincided, for the African artist also drew exclusively on elements in nature (usually the human figure) which enabled him to produce a plastic structure.

The great event in the evolution of western art was its rejection of the work of art conceived as an imitation of an existing reality, external to the work itself. The artist asserted his right to create his own shapes and to co-ordinate them in such a way that they led their own life, independently from any other reality. New forms were created, new structural combinations were introduced.

The 'discovery' of African art at this time worked as a catalyst. Although the purpose behind its creation was quite different, it was nevertheless lifted onto an aesthetic plane. It concentrated and stimulated the creative process, providing it with a goal, the first stage in its subsequent development. The statue or the mask, whose significance in religious worship was not yet properly taken into consideration, offered the European artist a synthesis of abstract forms, an 'architecture' based on surfaces, and the predominance of the circle and the cube. Most important of all, similarities in form developed: features were reduced to a

geometric structure of curves; volumes were pared down to standard relationships in size; a large structure based on two or three ground-planes evolved as did caricatures and linear representations. This concord demonstrates an influence. Nevertheless, Olivier Révault d'Allonnes was probably right when, on the occasion of an exhibition of Chad art in Paris, he wrote that the European artist was not interested in African art itself and for its own sake, but that the boldness of its statements had interested him in its customs and particular problems.

Apollinaire was already convinced that the artist's keen interest in African art was predominantly aesthetic. He remarked: 'In negro sculpture, no account is taken of the supernatural character with which it is endowed by the artists, who have created it, and the faithful, who worship it.' There is no doubt that the modern artist was only rarely inspired directly by works of primitive art, and that he was merely seeking to discover the laws governing its shapes. The parallel between primitive and modern art is almost entirely the result of our age's search for sculptural values.

There is a difference, however: the primitive work of art (as an object of religious worship or as a utensil) always has a meaning which is accessible to all those who are part of that culture, and it is always dominated by a symbol which determines the structure of the work even when all details are not concentrated upon it. The modern art work is not completely involved: it is an exception, an object for a collection or an exhibition. If it does have a symbolic significance, this is always arbitrary and individual.

The contemporary artist feels himself to be faced with problems that, it seems, can only be solved with the help of the discoveries of vanished civilizations. But the solutions offered by primitive art are entirely dependent on chance: they are secondary phenomena which can be traced back to the intellectual limitations of these peoples. Thus, the influence of African sculpture underlined the tendency to conceive of a work of art as a plastic structure.

Modern and primitive artists alike translated natural shapes into an abstract 'architecture' of forms. If there were other, deeper motives at the basis of this coincidence, it is nevertheless certain that the moderns did not at first give any proper account of this. There were all kinds of explanations.

Mechanised man, who lives in a highly complicated world and is swept along by a tempo with which he cannot keep pace, looks for simplicity and unity in his everyday life. This expresses itself in an antipathy for ornamentation in architecture, in furniture and everyday utensils: what he likes is simplicity and spontaneity, not refinement and falsification. Hence the strong attraction held for him by certain primitive artists.

This explanation, however superficial, shows that another, more profound one must exist.

In their search the great sculptors and painters of this century did not draw so much on the ancient Greek world, on the Middle Ages, on the art of the Far East and Africa, as on that which preceded all these, the archaic world. If the Parthenon friezes were still considered 'archaic' fifty years ago, today they are part of the classical world. They represent the slow flowering in the treatment of form that had already reached perfection in the Cyclades. Truly archaic art embraces Maya art, and that of the Pahouins (a negro tribe in the Congo), the Celts and the South Sea Islanders.

The boldness and power present in the first depictions of Apollo no longer startle us by their 'primitiveness'. We regard these early fusions of shapes as products of a geometric style. A wish for structure is directly expressed in them. The burning desire to dominate nature causes the artist to portray it in a ruthless, almost mathematical way. When the artists of the 20th century opposed the claustrophobia of academicism, they were attracted by primitive art, by a classical art which is far removed from its 'classicising' imitations. They were looking for forms

that were not yet controlled by pure matter. Above all they wanted an art which was the result of a spiritual need, and not a copy; the result of a decision that could be realized by the mind, and not by what was visible to the eye. Hence the break with Impressionism. The artist does not want to be a passive subject to his impressions; he takes possession of reality, in order to transform it how he pleases.

When the negro sculptor submits to a system of rules which mould his art and prescribe certain proportions, stances and dimensions, these formulae are part of a philosophy of life to which he subscribes and in which he lives. They have their place in a scale of values that is not imposed on the artist, but which he adopts without reservation. The distortions and disproportions in perspective are dictated by a universal hierarchy, a mental organization of the world in which every constraint has a deep and recognised significance. This hierarchy is closely bound up with the religious and spiritual ideas of these primitive communities. Primitive art is a religious art; for the religious artists, the 'canon' of his art is divine revelation. But a religion cannot be rediscovered at will, just as a myth cannot be manufactured.

Herein lies the fundamental distinction between primitive and modern art, despite a resemblance in form. Those elements which in modern art are merely aimless devices and variations in form, in primitive art are a formal necessity arising from a religious sense and guided by an inner compulsion.

It seems legitimate to ask whether the essence of African art has not been ignored with reason. The art of the negro races and their whole conception of the world are based on their religious understanding of the soul and on their belief in ancestors and spirits. The rejuvenation of artistic inspiration in the West Indies under the influence of negro art is a fact that cannot be denied. But has this influence been purely on form, or were there other deeper links between these two arts?

Bernard Dorival believes that Picasso was interested in African sculpture not simply from the point of view of art, but also because of its exciting, almost incantatory power, which is essentially magical; he found in it an answer to his longing for the realm of imagination. But the conclusion that Dorival draws concerning the supposed relationship between Picasso's art and negro art, is misleading: 'As in Picasso's case, it (negro art) is seeking to disrupt life, and to conjure up phantoms and monsters'. G. C. Argan, on the other hand, stresses that African art is orientated towards life. Otherwise he shares Dorival's view: 'For modern man, negro sculpture restores that essential invulnerability, that deep unity of self and the world, of which he has been deprived by the logical distinctions of rationalism and society's rigid structure. It is no longer a case, as it was with Gauguin, of an escape from historical time in order to discover primitive myth. The art of primitive peoples has taken its rightful place in history and has become the model for a new classicism'. Argan believes that the discovery of primitive art by the moderns arises from much more profound motives than the simple realization of a relationship acting as a catalyst between artistic conceptions of the world. It cannot be denied that the concentration of the artist's vision on more austere, starker forms, independent of the subject depicted, went hand in hand with an ever increasing knowledge of primitive art. The artist in the modern world is interested in the most diverse sculptures, whenever they coincide with his own ideas about form: his concern is to solve the problem of integrating volume and space without having recourse to the usual method of perspective. His way of understanding the purely artistic data – that is, through the imagination rather than simply visually – apparently corresponds to what might be called the intellectual realism of primitive art. For those artists too created a form of art which first and foremost transcribes what the mind knows, and not what the eye sees. They sifted out those elements which

seemed to lack interest even though they might catch the eye first, and instead depicted invisible things that they regarded as essential. Thus, for the negro, art contained no obligation to be realistic. Modern artists in their turn, gradually abandoned the claims of naturalism, replacing them with their own sculptural logic. Both modern and primitive artists were seeking to understand space logically, according to its simplest laws. For the negro artist the visual world was only rendered valid by transcendent forces; the modern artist lacked this justification.

This statement needs some qualification. Although a conscious justification may have been wanting, it may well be that there was a specific tendency in the spirit of the modern age to express oneself through an austerity of form similar to that in primitive art. Herbert Read was of this opinion: 'We would like to stress that there are conditions in the modern world which have parallels only in primitive times. What we propose to demonstrate in this exhibition (40,000 years of Modern Art) is that there is nothing unfamiliar in the human world, nothing even new in these modern art forms; they are the inevitable ways in which certain phases of human experience express themselves'.

In fact, we should not believe in a 'formal similarity', whatever it might be, for a shape is, first of all, always something more than a shape, while yet remaining pure form. As Focillon writes: 'If we want to understand properly, it is advisable to insist that form is always an "incarnation", in whatever shape it manifests itself'. The deep impression made by negro art cannot be reduced to a chance similarity in form.

Even though Western painters were not interested in the chthonic elements in African art – which were linked to its magic, religious character – and adopted its formal characteristics without concerning themselves with the spiritual foundations of these forms, this lack of awareness should not lead us to hasty conclusions. If the artist is not conscious of the forces behind the genesis of his art, this does not justify any inferences that may be made concerning the nature of these powers.

Cézanne, who probably did not know African art, wrote: 'Depict nature by means of the cylinder, the sphere and the cone all placed in perspective so that every facet of an object is turned towards the central point of a flat surface'. Cézanne thus explains to us his creative method. Using his perception of colour as a starting point he explores his emotions and finally arrives at a geometric reconstruction of nature which is based on the cylinder, the sphere and the cone and arranged according to the rules of perspective. A painting should be a construction from simplified forms, borrowed from nature, and not a copy of it. Cézanne and negro artists were both in search of an abstract art that would allow them to create a world parallel with nature but not identical to it. The question still remains whether the stimulus behind their quest for abstract art was the same, or at least a comparable one. We must stress again that it was not necessary for the artist to be conscious of what led him to abstraction. He can leave the explanations to the historians.

Abstraction and Empathy

We must not, moreover, spend too much time on this episode in art history. In 1908 Wilhelm Worringer's book *Abstraction and Empathy* appeared. The book was devoted entirely to the art of earlier ages, but was recognized as being of remarkable topicality.

Worringer noted that a need for abstraction exists alongside man's desire for fusion with nature. The wish to identify oneself with the world – which is the point of departure for every

artistic experience – is satisfied by the beauty of organic life. The need for abstraction, on the other hand, seeks gratification in the beauty of all that which denies this organic existence, in the crystalline world, quite simply in the abstract world of laws and necessity.

He drew attention to the fact that every primitive artist knows this hankering after abstraction, and he wondered what the mental conditions for such a desire might be. He sought it in the inner knowledge which these people gained of the world, and in their psychological acceptance of the universe. Even though this longing for fusion presupposes a bond of confidence – a genuinely pantheistic link between man and the world – the need for abstraction is the result of a profound inner disquiet in man when faced with the world; it corresponds, in a religious sphere, to a transcendental conception of the universe. The origins of this attitude lie in the terrible intellectual fear which man feels when confronted with the abyss of space.

Because they were tormented by the complexity and the heterogeneous forms of the external world, these 'primitive' peoples possessed an immense desire for peace and tranquillity. The potential happiness which they saw in art did not consist in immolating themselves to the material things of this world while still taking pleasure in the process, but in seizing upon some element in all its contingency and immortalising it by giving it an almost abstract expression. In this way, man hoped to find a safe footing, a place of repose amongst fleeting visions.

Worringer set out the following principle: the less mankind is able to understand the phenomena of the external world and, consequently, the less kinship he feels with them, the stronger is the impulse which drives him to create a powerful and abstract beauty. It is not that primitive man is searching for laws in nature, nor that he feels them more keenly than another: on the contrary, he experiences an even greater desire to free these phenomena from arbitrariness and chaos, because he feels lost and overpowered by them. So he endows them with the urgency and the value of law.

For primitive man, artistic creativity represents an escape from the capriciousness of life. He lives from day to day, and from hand to mouth, in the literal sense of the word. In his world, records of permanence and durability are unknown. It is still impossible today to make a native of a tribe, which nevertheless has had contact with civilization, really understand what a promise means. He sees only the immediate situation, he reacts instinctively to events. Therefore, when he produces a work of art – a magical act of possession – he escapes from the arbitrariness which rules his life. For him what he creates is the visible expression of the absolute. For a moment he has halted the passing of his life and produced a lasting and permanent work. Out of time he has fashioned space; he has enclosed it within an outline. An expressive form has been generated under the impulse of this inner emotion. He has created order, a unity, an equivalent in form to his feelings.

It is evident that the motives which compel the modern artist to create a certain formal rigour do not necessarily have to be the same. But is Lévi-Strauss right when, in the case of Picasso, he sees the inner necessity of the primitive replaced by what he calls 'a kind of pulverization of artistic canons'? Are we dealing here with a second rate interpretation, a remarkable statement about the artistic act? And can we say that what had a metaphysical significance originally in primitive art has now been reduced to what may be called 'inner decoration'? The reaction which Picasso's work provokes in Lévi-Strauss arises from its fundamentally rhetorical character and from the inadequacy of modern art.

It would seem, then, that negro art represents primarily a borrowed formula for the moderns, a collection of rules to be imitated. Whereas negro art is a language, an integrated art, the work

of a Picasso – despite the inspiration it afforded him – is no more than a straitjacket imposed afresh each day by man upon himself. As such, it helps to limit the infinity of space which is denied him; here, where he sees nothing but his own works, man can believe that he is content.

Claude Lévi-Strauss, who conceives of art as a system of signs, considers art to be profoundly integrated with the life of the community. It is therefore, always a language, and thus a system, or an amalgamation of systems, with meaning. According to Lévi-Strauss, a language which is dependent upon aesthetic emotion – as is abstract art – is only the poetic expression of an individual. But this has nothing to do with true language. Or, rather, such an art form ends up by being what Lévi-Strauss calls a pseudo-language: it is a caricature of language, a mirage, a kind of infantile game on the theme of language, which does not lead to genuine significance.

The art of primitive civilizations possesses a great wealth of symbols. Every object, even the most practical is, as it were, a reservoir of symbols, which are not accessible merely to their creator, but to all users.

A work of art has a collective function. Such a task still exists, not in a metaphysical sense, but in the need to achieve a theory of mental comprehension. This comprehension is closely bound up with a system of symbols that have the same meaning for the artist as for the group which he is addressing. Outside these common symbols there can be no language, no communication.

For this reason, Lévi-Strauss considers the esteem given to negro art by Europeans to be doomed to superficial aestheticism.

Picasso and Negro Art

Art historians are still debating as to whether Picasso was influenced by negro or Iberian art in *Les Demoiselles d' Avignon*. Picasso himself declared to Zervos that at this time he still did not know black African art: 'It was only later revealed to me. One day, when I was leaving the Musée de Sculptures comparées, which then occupied the left wing of the Trocadéro, curiosity prompted me to open the doors leading into the rooms of the old ethnographical museum.' Despite the events of the war, which deeply affected him, Picasso was still talking in 1942 – more than thirty years later – with great emotion of the amazement which had overcome him at the sight of these African sculptures.

But in relating this, he seemed to have forgotten the sculptures he had seen at Derain's; they clearly influenced *Les Demoiselles*, even though the ostensible influence of Iberian sculpture predominates.

Apollinaire, who had come into contact with African art through Vlaminck, Derain and Matisse, and who owned the famous *Oiseau bénin* (the Benevolent Bird) to which he compared Picasso in *Poète assassiné*, refused to accept the audacity of this picture. He called it 'a philosphical brothel'. Picasso's earlier 'blue' and 'pink' periods were nowhere to be seen. As Marcel Adéma said, the faces of people on a lovely day had become like the grotesque images of Congo deities. We recall Apollinare's opinion of negro art: 'A certain audacity of taste has caused these negro idols to be considered as authentic works of art'.

It is the result of lengthy exploration: *Les Demoiselles d'Avignon* breaks with traditional forms and initiates a decisive change in modern art. The frontal depiction of the eye in the left hand figure is reminiscent of Egyptian painting, while the figures on the right clearly betray the

influence of Congo masks. Nor does Herbert Read take seriously Picasso's assertion that he only became familiar with negro art after completing his picture. When we look at this painting, it strikes us immediately that Picasso had already experienced African art at the time he was working on it. The two figures on the right, as Read established, are directly influenced by negro art. De Rachewiltz quotes Madame Buffet-Picabia in support of this: 'Picasso had discovered his path with the aid of negro art'.

The same influence was unequivocally present in his works from 1907 to 1908 which have been labelled Picasso's 'Période nègre'. In the *Ballerina* of 1907, the artist was clearly inspired by the tomb sculptures of the Bakota tribe. The *Head* painted in the same period, recalls the masks of the Congo or the Ivory Coast, as do a whole series of drawings and sketches published by Zervos.

The same influence characterizes Picasso's wood sculptures from 1907, during the period often known as pre-Cubist: ones like *Bambola* and *L'homme debout* (Standing man). The dissection into surfaces, the synthesis of forms which are reduced to fundamentals, the legs merging into the base or sketchily modelled: all these elements belong to the purest African traditions. It is clear that Picasso's discovery of African art at this time acted as a catalyst.

The reasons why a painter like Picasso should deny the catalysing effect of African art on his own work are linked with his psychology as an artist. From a historical point of view there can be no shadow of a doubt that Picasso came into contact with African art. Nevertheless, there are still historians who do not wish to admit these facts. Maurice Raynal is one. In 1927 he wrote that in 1907 Picasso was painting under the influence of 'Cézannism' and negro art. In 1950 he contradicted what he wrote in 1927, now asserting that 'Picasso always defends himself against the suggestion that he has been inspired by negro art', which according to his own statement, he only discovered in the ethnographical museum after completing his picture. Kahnweiler affirms that Picasso's pictures showed only an intellectual affinity with negro art and that the influence of this art continued to have an effect long after the so-called 'negro period' had ended. Pierre Level goes even further. He denies any influence, saying 'there is no trace of any imitation of these ritual figures at any time in his long Cubist period.'

We find the opposite view in Pierre du Colombier. He asserts that Derain had introduced Picasso to negro art in 1905, a fact confirmed by several sources. Janneau even mentions the year 1902, which is unlikely. But an irreproachable witness, Gertrude Stein, writes that Vlaminck had shown African masks to Picasso in 1906–7 and that it was Matisse who had made Picasso familiar with them. We have to accept that Picasso's protestation that he did not know African art at this time is a distortion of the truth. There can be no doubt that negro art had exercised a direct influence on the two right hand figures of *Les Demoiselles*, completed in 1907, as well as in *Femme aux mains croisées* (1907), *Deux Femmes nues* (1908), *Trois femmes assises* (1907–8), *Femme à la mandoline* (1909) and also in *Tête de femme* (1907), in the Cooper collection.

Picasso's art provides us with a striking example of an artist whose work is concerned, in multifarious ways, with all the means of expression in plastic art which have been used in the history of mankind. Braque said of him: 'he speaks all languages'. Whoever flicks through Pierre de Campris' strange book *Picasso, ombre et soleil* (Picasso, shadow and sunlight) will find Braque's report undeniably confirmed. There was as yet no multifaceted work of this standard. One of the fundamental characteristics of his work is the way art is constantly being called into question. It is pointless to argue about whether African sculpture played a part in his general enquiry or not.

Matisse or Vlaminck

Numerous witnesses attest the fact that Derain first showed Picasso an African mask in 1905. Derain acquired it; it had been discovered by Vlaminck in a bar on the banks of the Seine. 'One afternoon in 1905,' Vlaminck relates, 'I was in Argenteuil. I had just come from painting the Seine, the sailing boats, the hill. The sun was beating down. I took my canvas under my arm, with my paints and brushes that I had packed up, and went into a bar. Sailors and coaltrimmers were standing at the counter. As I refreshed myself with a glass of white wine and soda water, I noticed three negro sculptures amid glasses of Pernod, Anisette and Curaçao. Two were statuettes from Dahomey, made in red and yellow ochre, and white: the other, from the Ivory Coast, was quite black. After working for three hours in the blazing sun, had I come here on their account? Or was it the singular mood I was in that day? Or did these figures correspond to specific subjects for reflection that often occupied my thoughts? These three sculptures amazed me. I felt instinctively the power they contained. They revealed negro art to me.

Derain and I had combed the Trocadéro museum several times from end to end, but neither had ever seen anything in the objects on display, other than – as was normal at that time – barbaric fetishes. We had always missed that expression of primitive art. The three negro statuettes in the bistro at Argenteuil spoke to me quite differently. I was shaken to my very core. I asked the owner if he would sell them to me. At first he refused. I persisted, and, after divers hesitations, refusals and excuses, he gave them to me on the condition that I stood a round of robust red wine; and so I took the statues with me.

Shortly afterwards a friend of my father, to whom I had shown my acquisitions, offered to give me some statues he owned, since his wife wanted to throw these ''revolting objects'' into the dustbin. I went to see him and took a large white mask and two splendid statues from the Ivory Coast away with me. I hung the white mask over my bed. I was both delighted and confused. I was seeing negro art in all its primitive nature and all its majesty. When Derain came to see me, the sight of the mask rendered him speechless. He almost lost his breath and offered me twenty-one francs if I would give it to him. I refused. A week later he offered me fifty. That day I did not have a penny: I accepted. He took the piece away and hung it in his studio in Rue Tourlaque. When Picasso and Matisse saw the mask there, they too were overcome. From that day the hunt for negro art was on.'

It was Picasso who, after Vlaminck, realized the uses to which the plastic art of the African negroes and the South Sea Islanders could be put. He introduced them progressively into his art. He took forms apart, elongated them and put them together again. When he transferred them to the surface of the canvas, he spread it with a mixture which he tinted with ochre red, black and ochre yellow, as negroes do with 'Tapas' and fetishes.

The account given by Vlaminck in his autobiography was confirmed in an article by Apollinaire in 1912. He wrote: 'Continually stimulated by artistic discoveries, Maurice Vlaminck had acquired many sculptures during his walks through villages along the banks of the Seine: masks, carved fetishes in wood, works by negro artists in French Africa that had been imported by sailors or explorers. Doubtless he found in these grotesque and vaguely mystic works analogies with the paintings, drawings and sculptures of Gauguin. The latter had drawn his inspiration either from the representations of the Calvary he had seen in Brittany or the primitive sculptures of the South Seas to which he retreated in order to escape European civilization'.

Umbro Apollonio shares Apollinaire's view: 'At a time when the Impressionists had finally freed painting from the straitjacket of academicism, Maurice Vlaminck's taste for negro

sculpture and André Derain's reflections on these bizarre objects exercised a decisive influence on the destiny of French art'. Apollonio wondered why Vlaminck was fascinated by this negro sculpture, which Derain was to show Matisse and Picasso; and he replied: because Vlaminck encountered expressionist tendencies which correspnded to his artistic aims at that time. To him it was unimportant whether Picasso had known of negro art before 1907 or not. Other accounts besides Vlaminck's corroborate the fact. They also concern the mask that Derain owned. Matisse, in his turn, acquired a statuette from the Ivory Coast, and this was in 1906, the same year he met Picasso. Probably they both discussed this topic. In any case this is only a small matter which can be ignored; nevertheless, there is a clear similarity between certain dissections of form in *Les Demoiselles* and the schematic nature of Congo sculpture, even if Picasso's schematization originates in ancient Iberian art. It is possible that the painter blended features of archaic art with those of a primitive culture in the course of his work.

According to Pierre Courthion, Matisse – if we may put it thus – was the real discoverer of negro art. 'I came to it directly' he told Courthion. 'I often used to pass a curio shop, "Père sauvage", in the Rue de Rennes. I saw a variety of harness breast plates displayed in show cases, and also, right in the corner, little wooden statuettes of negro origin. I was astonished by how they were conceived from the viewpoint of the sculptor; they were close to the works of the Egyptians. Compared to European sculpture, which takes its point of departure from muscular shapes, and, above all, from the description of the object, these negro statues had a shape appropriate to the subject, they were systematic and imaginatively proportioned. I often used to gaze at them. One day I went in. I bought one of these sculptures for fifty francs. I went to see the Steins, who were Americans in the Rue de Fleurus in Paris. Michael and Sarah Stein had an important collection of Chinese art. They bought paintings from me that they rather valued because of their exotic appearance. They also bought from Picasso.

I showed my statuette to Gertrude Stein. Picasso arrived. We chatted. It was on this occasion that Picasso first became aware of negro sculpture. After this, Derain bought a large mask, and negro art became of major interest for avant-garde artists!'

African art excited Matisse and Picasso and led to an awareness of primitive art that is characteristic of the Fauve era. The sculptures which Matisse did in 1908 are reminiscent of the *Woman of Temme* (Sierra Leone), one of the rare works of African art that is startling for its elegance of form. In its slender figure, its ornaments of precious gems, its girdle, and its unique face, this work shows a remarkable modernity. Even van Dongen, whose work does not exhibit any direct negro influence, owned some works of negro art. In his case, the intensity that emanates from these shapes originates in the elemental forces expressed by them. Picasso and Braque were more interested in the plastic arrangement of form than in the brute power characteristic of primitive art. The spiritual affinities with South Sea sculpture that one finds in certain German painters are completely lacking in France.

What attracted painters to sculpture becomes clear when we consider the formal problems they faced. This is not to imply that they approached the plastic arts with the same notions as painting, on the contrary: what drew them to sculpture was the fact that it allowed them other concepts, suggested other ways in which to solve the new problems of plastic representation.

Hence the freedom and animation in the sculptures of these two painters. They were not at all concerned with traditional rules of sculpture. They set to work without preconceived ideas. In a certain sense they accepted no responsibility. For them, sculpture was 'a voluntary act', and 'experience without obligations'. They devoted themselves to sculpture in order to search for a direct link with the subject, without the intermediary of colour; and to solve the problems of form by means of movement and light.

Problems of Form: Derain, Modigliani, Brancusi

Derain became interested in sculpture for the first time in about 1906, when he discovered African art. Shapes found in black art were being introduced into modern sculpture: the squatting man, the standing woman, her head laid on her shoulder in a gesture of resignation to the weight of a solid mass, a female head whose long face is reduced to a rectangle. Derain used the sculptural language of several peoples to deepen and broaden his inner life. As a result he regarded the language of the sculptor not as an immutable law but as a point of departure for his own explorations.

Derain has often been reproached with being only superficially concerned with primitive art, with having a merely academic interest in it and lacking in emotion. It was pointed out in his defence, that Derain was not content simply with reproductions, or with works that were to be found in museums, but that he collected these art objects himself wherever he could. He wanted them to be part of his daily existence. During his lifetime, he collected truly remarkable and astonishingly diverse works of primitive art. He began with the mask that Vlaminck owned, and which he bought in 1905.

In 1909 Modigliani made the acquaintance of Brancusi. In the autumn of 1909 he returned to Leghorn and it is known that he produced a great deal of sculpture during this stay in Italy. Brancusi had encouraged him to do so. It is probable that no work from this decisive period in Modigliani's development still exists. The artist himself threw everything that he had produced in 1909 into a canal in Leghorn. It seems that he suffered such crises of iconoclasm. Later, on his return to Paris, he devoted himself again to sculpture. The awareness he gained through sculpture enabled him to find his own means of expression in painting. In 1909 Modigliani had left the right bank of the Seine to settle in Montparnasse. It was here that the sculptor Lipchitz came to know him. 'When I came to see him,' Lipchitz recalls, 'he was working outside. Several heads in stone, perhaps five, were set up on the cement paving of the courtyard in front of his studio. He was arranging them. I can still see him in front of me, bent over these heads. He explained to me that he imagined them as a whole'.

As a result of his lengthy discussions with the sculptor Brancusi, Modigliani became convinced that Rodin had led sculpture into a cul-de-sac. He rejected the process of modelling, which he considered harmful, and sought a technique which was more suited to express his sculptural ideal.

If we wish to define this ideal, we must immediately think of the characteristic features of African sculpture and of the first modern works: those by Nadelmann, Lehmbruck and Brancusi. Modigliani, who followed the examples of certain African styles, systematically elongated his faces and gave the neck its own characteristic shape. He dissected basic forms so utterly into geometric figures that his heads formed merely one complete mass with the body; the nose – just as in African sculpture – dominates an elongated profile. Without doubt the influence of African sculpture is decisive, especially between 1909 and 1913, but Modigliani's work also has certain similarities with Gothic and ancient sculpture, particularly when he was almost exclusively concerned with stone carving.

Modigliani achieved his spiritual intensity by moving towards an expressive abstraction in organic forms. The structure of his heads is close to the stark atmosphere of primitive and archaic art as far as the revaluation of fundamental dimensions is concerned. The influence of the close links between Modigliani and Brancusi is evident here. In this connection Brancusi's head (1907/8) in the Philadelphia Museum and the female head by Modigliani in the Museum of Modern Art in Paris should be compared.

Brancusi's debut confirms the rule that the simplest forms convey the richest meanings. The more complete a form is, the more successfully it will encompass the 'universe'. A sculpture like the *Baiser* (the Kiss) carries the observer back to primitive sources, far from European traditions. Brancusi was amazed at the clarity of form in African sculpture: it was precisely this that he himself was seeking in 1914. Brancusi's wood sculptures have their origins in an infathomable, magic universe where man confronts demons face to face, and where he is denied light. It has been said, with reason, of Brancusi that he does not need to discover the primitive world, because he already carries it within him.

Nevertheless, nearly all historians concur in stressing the significance that African art had for Brancusi, although he himself had always denied its influence on his work, despite its primitive character, which does indeed seem to be related to African art. Cardnuff-Ritchie is probably closer to the truth when he affirms that Brancusi's personal contribution outside the Rumanian folk tradition lies in having understood how to blend the barbaric power of African and prehistoric sculpture with the deep spirituality of the Hindus and Chinese. Julio Gonzalez, encouraged by Brancusi, abandoned painting in 1927 to devote himself entirely to sculpture. He produced a series of iron masks which show that he had in the meantime outgrown the influence of the Cubists. In a few years he had succeeded in finding his own mode of self expression; he did not merely invent new shapes, but also a new method by which he exploited all the possibilities afforded him by iron. He re-invested this material with that original dignity of which it had until then been deprived.

Until then? That is not quite right. For the Africans had had the idea of using iron and pieces of iron long before the Europeans. In the Musée de l'Homme stands an African figure: the god Gou. It is an early precursor of the 20th-century use of metals in sculpture. The works of a whole generation of sculptors follow in its wake: Picasso, Gargallo, Gonzalez and later Chillida, César and Kemmeny. All these sculptors have something in common with negro artists. The desire to use a material in their works which was otherwise only used for practical purposes.

Since 1945 there have been numerous sculptors who have used scrap iron for their works as did an African artist from the Fon tribe in Dahomey in 1860, when he created his god Gou. In fact, this statue consists of an abundance of old tools, weapons, and tins which had been thrown out and gone rusty. This statue is far removed from any form of naturalism; the drastically simplified forms lend it a magic starkness.

Gonzalez' *Montserrat*, a 1936–7 memorial to his people stricken by civil war, is strongly reminiscent of this agricultural and war god of the Fon tribe. Admittedly this influence cannot be proved but the series of masks which Gonzalez began in 1930 betrays the influence of these exotic models.

Picasso used Gonzalez' advice in his iron work, and sometimes even handed the execution of it over to him. Around 1906 Picasso broke with illusionist naturalism. He dispensed with every individual feature, and his figures took on the anonymity of masks. In the years that followed he continued in this direction. The 'primitivism' of his style can be traced back to the sculpture of black Africa.

The major concern of this period is the emphasis on the volume of different bodies; it is also found in the painting of this era. With the *Demoiselles d'Avignon*, Picasso introduced cubism whose aim was to grasp the physical reality of everything that exists.

Encounter or exchange of techniques

Every encounter which triggers off fundamental changes leaves deep marks. Usually every major artist takes part in the dialogue. But in the encounter between modern and primitive art, only the modern artist plays an active role. It is only the presence of primitive art which is important for him.

Primitive art was indifferent to any influences, except in isolated cases which are already history. In Benin, for instance, we can see the effect of the fusion of Portuguese and Arabic civilizations.

Despite all this, it would not be correct to look for an influence in the sense of an imitation. What interested the Cubist, for example, in negro art, was undoubtedly its pure plasticity, its rigorous structure. But it would also be an exaggeration to trace the destruction and reconstruction of volume by the Cubists back to the influence of negro sculpture. What was evident was a concurrence, a particular artistic receptiveness; such a susceptibility dates from this era, which turned itself towards unearthed art forms of history.

If, in this book we have compared a number of modern works of art with primitive ones, we have done so in the belief that the evident affinities between these works are in no way coincidental. The influence of prehistoric and primitive art is admittedly not always direct; it is precisely the profound causes for this overlap, discussed here, that allow us to see an influence where none may be directly recognisable in the forms themselves.

For this reason we have practised great restraint in these comparisons. Some paintings, like those of Léger, Nolde and others, reveal a purely external assimilation of the primitive work of art. But the name of Nolde alone is enough to show that the influence of primitive art must, in every case, go too deep for it to be purely attributable to the chance presence of one object.

The term 'primitive' here comprises the art of prehistory and of primitive peoples. The latter are those who have not produced any highly advanced civilization, and whose ways of life have remained at a prehistoric level – peoples who do not yet know how to write, are without towns, and who still preserve those ways of life.

It is only rarely that an influence can be shown and it is almost impossible to prove it. This book will deal only exceptionally with such proofs, as in the case of Picasso, for example. Instead we are attempting to demonstrate that a relationship does emerge when, at a specific moment of receptivity, forms that correspond to this receptivity are unconsciously assimilated, even though they were created in a completely different age and place.

Whenever an artist becomes interested in constructing an integral form with the aid of basic, solid masses he must also be capable of absorbing what has been produced through the ages in that same field, even if this is at the most remote outposts in the history of art. It would be inaccurate in such cases to speak of direct influence. This receptivity to exotic forms occurred at the same time as the collapse of a well-established tradition that had remained alive until the end of the 19th century. It stretched back as far as classical Greece. But in the course of the 20th century the whole hierarchy of aesthetic values was upturned. Valéry, who had spoken of the 'literature of decadence', defined the new situation thus: 'Today we see works of every diverse types emerge within very short spaces of time and even exist side by side; they are works which, as far as their external characteristics are concerned, belong to very different eras. One will show an unrivalled naiveté, always defective in some way, more childlike than the work of a child; another is the creation of a savage or a being of varying intelligence, fallen from some other planet'.

The dominant impression received by Valéry was that discord prevailed; it was a confusion

that presaged the end of all art. What was curious was that the artists who had produced this cacophony were 'very closely related'. They had read the same books, and newspapers, attended the same schools, and visited the same exhibitions. But their art did not give the impression of a return to a common tradition; on the contrary, it seemed to be the result of a complete uprooting. In fact, such a tradition or continuity in European art, no longer existed.

For the painters of the second half of the 20th century, art began at zero, or, rather, with Mondrian and Kandinsky or Duchamps and Dubuffet. Instead of turning towards inherited tradition they sought connections with the most distant civilizations, both in space and in time, in their 'Musée imaginaire'.

The question, which has yet to be answered, is this: is the spirit of quest in all styles and forms of art based on the recognition that a universal character exists, or, better, do these forms from the past provide the modern artist with a supply, an arsenal of motifs on which he draws in order to pursue his own experiments in technique?

Julien Gracq claims that modern painting has even sacrificed its essence to technical experimentation. The suppression of depth in still-life painting, the dissection of shapes into many-faceted structures that create new volumes, sketchy modelling and so on, all of which are purely questions of technique, have become basic prerequisites in modern painting.

The justification of a technique is that it should allow a temperament to express itself. Technique really does not mean very much if it is not incorporated within the framework of a desire for self-expression that finds an adequate outlet in that technique. For this reason there is no such thing as 'unique' or 'true' technique. Each one is equally valid.

As soon as technique becomes the style of an era, it is subject to the laws of the moment. The style of a particular area – its technique – is what dates first in a work of art. What does not age is the individual stamp, the colour harmonies, the power behind the shapes, the unity of structure, the musicality of the rhythms and rich vitality of the subject matter: these are all features which will be valid for the pictures of any age. As soon as this personal style is overtaken by the style of the age, the painting will be outmoded in a few decades, or even earlier. 20th-century art thus becomes a succession of changing techniques, the storehouse of an inexhaustible past, almost a supplier of opportunities and themes authorizing such technical diversity.

Is it therefore genuinely possible to conclude that the encounter between modern and primitive art is a meeting of techniques? When we claim this, we must not forget that the technical aspect of their art only played an incidental role for the primitive peoples, whereas it is a fundamental condition of modern art. Consequently, the magical, mythical, symbolic and intellectual elements of primitive art are lacking in the moderns.

We ought to ask at this point whether it was so easy for modern painters to grasp primitive art thoroughly. Did they lack a proper understanding of the necessary conditions because of insuperable barriers? One might reply that 20th-century man has realized the shortcomings of intellectualism. He is aware of his situation: now he stands afresh before something that defies intellectual comprehension, something which can only be experienced in a non-intellectual way; he is face to face with the mysterious depths of the world. But this means that he is contributing to the bankruptcy of his metaphysical knowledge.

This bankruptcy, which has exposed the limitations of intellectualism and the possibility of an absolute conception of the world derived from the divine, appears to open the door to a new and authentically religious world. Religion and metaphysics once again seem to be able to grow in the same soil.

Artists who were the first to notice this intellectual bankruptcy, were also the first to look for

a fundamental experience that would enrich their creative powers. It seems that they felt a kinship with an art which is rooted in religion, as is that of the primitives.

The painters of German Expressionism especially, though they were loath to admit that art plays a sociological role, nevertheless believed in the possibility of a socially rooted art. They believed in an art in which the blood of life still pulsed. They were looking for an art that had not yet been secularized, a form of painting given sanction by the metaphysical world.

Man's evolution is characterized by an increasing conquest of knowledge, as well as by this intellectualizing process; the latter favoured the former to a certain extent, and this dominance of reason was also partly the result of numerous experiences gained in the course of history. It was possible to comprehend the supernatural, if one crossed the boundary; but men did not know how to control this conquest of consciousness.

It has been noted that the magical conception of the world, inherited from primitive peoples, is the result of a profound anguish; it seems clear that this conception is a human creation, born of the psychological circumstances surrounding that fear.

Primitive religions, which retain an authentic bond with magical and mystical beliefs, still exist where knowledge is concerned with ultimate things, or has not yet emerged. Now that metaphysics based on intellect has collapsed, the modern world knows no possible authentic metaphysics.

There are, indeed, individual attempts to grasp the transcendent world; but the most common solution is to try and escape from the doubts and bankruptcy of intellectualism by searching a deliberate fresh naiveté. If this is not feasible, the artist escapes into childhood, like Klee, into intoxication like Michaux, into infantilism like the Cobra artists, into the world of objects like Art brut; or else he equates the mass culture of the big cities with folk art, as Pop art does. These phenomena are the manifestations of the different forms of anti-intellectual primitivism. This is not a value judgement, but it does call into question the relationship between this art and that of the primitives; the power of the latter has its origins in a completely different world.

The exotic attraction of distant lands

At the turn of the century, the prevailing mood was one of longing to return to a primitive simplicity. Man, sated and disgusted, averted his gaze from the future and turned towards the past. Would that he could overcome the chaos of his petty life, painstakingly elaborated in the western world over the centuries! If only he could begin again to model life according to the simplest and most natural principles! 'Would that I could return to my mother's womb!' cries the robber Karl Moor at the end of his turbulent and senseless life.

Such attacks of nostalgia are familiar to the individual: who has not fervently wished that he could live his life all over again! But when this ardent desire, born of despair and a renewed will to live, takes possession of whole peoples and nations, this is quite a different thing.

There had already been some attempts to return to nature in the 18th century. It was at this time that civilization, which, historically speaking, begins with what we call the modern age, took the wrong road. Everything that man had set in motion with his great discoveries conspired against him. Civilized man was suffocating in the net of the difficulties which he himself had woven. He was searching for fresh air so that he could at last breathe deeply. It seemed impossible to disentangle the knots in the multifarious conceptions of life in the

western world. It was thought that only a radical remedy would permit some dim hope to emerge. People turned to primitive tribes: could they not teach us how to live a better life? Nevertheless, this movement bore the stamp of its own century, of a predilection for frivolity. It was scarcely more than a flirtation, a new toy. The irony in the *Lettres Persanes* paved the way. The preromanticism of Rousseau followed. Jean-Jacques' appeal, calling for a return to nature, away from the artificiality that disgusted him, contributed to the taking of primitive peoples as a starting point. There was a general conviction that man was by nature good, that he exemplified noble attributes that had been corrupted by civilization. This way of seeing things gave rise to the enthusiasm for the exoticism of distant lands: the island of Tahiti has played an important part ever since. France, the real centre of all cultural excesses, became the source of these new tendencies, although the reaction was transmitted to Germany: a sweet shudder that evoked those regions of the world where the emotions and forms of simple life still dominated, where respect inspired a childlike purity, a purity that men hoped to rediscover in primitive peoples.

At the time of the 'Sturm und Drang', the English garden, which respected nature's freedom, was more highly regarded than the French park with its conventional and strictly laid-out grounds. The English garden was not concerned solely with ruins and Japanese tea houses, but also with the huts of savages, symbols of an existence without restraints.

However, in reality, people were far from taking all this seriously. Seemingly, there was a vague belief that solutions for all these evils could doubtless be found in these remote lands; but men felt too comfortable in the fetters of tradition to wish to break them at all costs. Nevertheless, these tendencies, however trivial they may have been, contributed to the forces that prepared the way for the Revolution, this genuine hurricane which swept and drove away the fragile skiff of exoticism. At the moment when state and religion were separated in Europe itself, and the calendar moved back to the year dot, there was no longer any need in the west to look to primitive peoples for support; it is here that the great illusion created by the Revolution is fully revealed. It was very soon noticed that the evils caused by civilization were far too deeply rooted even for the draconian tyranny of the guillotine to heal. It was only a passing storm, bloody and terrible. But when the thunder died away, the earth appeared as loathsome as before. Nothing in human nature had changed.

So, between the interludes of war and the Revolution, civilization bloomed again, as cheerfully and as unaltered as if nothing had happened; the dictatorship of the machine spread, this time to an uprecedented degree, so that when the old nostalgia re-appeared, it attacked the very core, directly, and established its control even more profoundly than before. But let us have no illusions regarding the extent and bustle of civilization's increasingly uncontrolled and gigantic fairground! From the depths of the human soul rises the same insatiable desire to create new forms of thought, feeling, being and living, and thus to base itself on primitive experience. Carl G. Jung pointed out to what degree the figure of Wotan corresponds to a fundamental characteristic of the German spirit. He represents a herald from beyond the sphere of reason, a tornado that descends upon civilization when it is diseased and ripe for destruction. According to Jung national socialism was a resurrection of Wotan: man turns his back on civilization, and towards the deep abyss of a primitive past.

The artistic world also felt a burning desire to plunge into primitive sources. When Gauguin fled Paris to Brittany, then, in his dissatisfaction, crossed the ocean to Martinique and to Tahiti, he was obeying this compulsion to live, to see, to paint something different, to find human beings with healthy bodies and another colour. We can see how profound this experience then became, and how, amid the splendid colours of these tropical lands, in

contact with these tribes, and with his loved ones, the great mystery of rejuvenation was revealed to him; he realized the individuality of his life as a man of his age. His painting remained under the influence of Paris. His desire to achieve good taste, a certain overly self-conscious art, and a vestige of concealed sentimentality are still present in his work.

But whoever has read *Noa-Noa* knows that Gauguin the man succeeded where Gauguin the painter failed.

It is possible to say that Gauguin's pilgrimage overseas was the basis for a new attitude towards primitive races: from this moment on they were seen from an artistic viewpoint. What had been known about them hitherto, was mainly founded on what ethnology had taught men. It was generally believed that 'savage tribes' occupied a fairly low position in all spheres of human evolution and that their artistic capabilities were very remote from what – in accordance with the canons and standards of European art – was considered to be a work of art. They would never have reached western civilization unless people had become convinced of their superiority; and even less so in the 19th century when only works that conformed to the accepted rules were deemed to be perfect. Indeed, according to the opinion of the time, the instinct of these primitive peoples, who still remained outside civilization, would never have been capable of producing works whose significance might have surpassed those of Europe, the lord of the world. Such an idea would have provoked the derision of a whole century. What it saw was interesting and noteworthy only with regard to its subject matter and its aspirations. A completely different intellectual and spiritual mood had to prevail before these prejudices could be overcome.

Primitive art and German Expressionism

But before these aesthetic preconceptions could be overcome, some artists had already suspected the importance of primitive art. From his very first encounter with the sculpture of the South Sea Islands, Nolde felt himself drawn by the sensuous charm of its savage, uninhibited colours as well as its simple majesty. But undoubtedly the German painter felt even more strongly that there existed in the primitive external appearance of this technically and formally perfect art a search that had fundamental affinities with his own. It was neither inner poverty nor a jaded disgust with western civilization that drove him to the South Sea Islands; instead it was the need to free himself from the turmoil of his inner visions by contemplating an alien and entirely fresh reality. The crucial element, however, was the irresistible attraction exercised by primitive humanity on all those who live in the innermost realms of their being. This 'primitiveness' provides them with something complete, rich in mystery; it is not what is generally understood by the usual, wrongly used term 'primitive'. Nolde was guided by his belief that the remote past exists in all of us; he was convinced that our subconscious is still linked to the dawn of human consciousness, and that the divine being discloses itself in primitive tribes' ideas about the gods.

Another German painter, Max Pechstein, who also belonged to the expressionist movement like Nolde, had been filled with enthusiasm for South Sea Island sculpture very early on. He had long wished to extend and deepen his impressions of it. He wanted to return to its sources in order to lose himself in a world that was not in the grip of scientific knowledge and western tradition; a world whose unpretentious simplicity amid nature shone forth in its people, its objects and its way of life. Pechstein undertook his journey in April 1914 and reached the island of Palau after six weeks. When war broke out he was forced to return to Germany. But in

his paintings of Palau, the exotic allusions are only introduced to give emphasis to what the painter wishes to express. What Pechstein, unlike Nolde, retained from the primitives, was their subject matter. His encounter with their art had almost no influence on the formal element in his work, it simply furnished him with material. In this respect Pechstein is an exception in Germany.

The Germans and the French discovered African and South Sea Island art almost at the same time. Many painters in Paris used this material for formal purposes: Modigliani for example, in his elegant, stylized paintings; the Fauves, and even Picasso, in their eclectic studies of form. The Germans, on the other hand, were above all concerned with the spirit behind these art forms. Their works were not so much 'primitive' in form (as was the case with the French) as in their conception, which only rarely adopted the particular shapes of primitive art. It has been pointed out that the French regarded their African and Pacific models merely as objects of interest that could be dissected and used at the discretion of the individual. According to Bernard Meyers, the Germans saw an authentic art in these objects, and no-one had the right to detach parts from them at will. On the contrary, such an art should be the spark that animates inspiration and prompts the artist to realize his own goals.

Meyers bases these claims on explanations by Kandinsky and others. In Kirchner, for example, there are few exotic forms that have been borrowed directly from primitive art; nevertheless, it cannot be denied that many of his works are 'primitive'.

It was only after 1917 that Pechstein could collect together the drawings and sketches he had made on the island of Palau. With their aid and his memory of the landscape he began to produce a great number of paintings, engravings, lithographs, drawings and sculptures; they are all based on the impressions he received on the island. He covered his pictures with strong, savage colours; most of his fragmented shapes are too carefully modelled on his exotic prototypes to create the impression of being authentically primitive. Compared with the more spontaneous first sketches, his paintings, such as *Triptych of Palau* of 1917, that seems rather mannered, reveal the stiffness and forced nature of his evocation of the South Seas. Meyers claims that though Pechstein sought to paint primitive forces and an innocent existence, his creations do not attain an authentic, expressionist symbolism. They are no more than decorative compositions with a well-orchestrated rhythm: their very diverse components are not emphasised by intensity of feeling, but are held together only by a banal orderliness. Superficially, the figures whose world is depicted in these pictures seem to be well integrated into their surroundings, but if one thinks of the energy that emanates from the nudes in the open air (1911–12), Pechstein's later works leave much to be desired. Otto Mueller is characterized by the fusion of a certain decadent stance and a way of life which is still healthy, like that which is solitary and pitiful gypsy troupes lead. His paintings show no great response to the resolute appeal of Rousseau: 'Back to Nature'. His art is neither a lyrical escape into a dream paradise, as in Gauguin's case, nor a deliberate return to primitive simplicity as in Pechstein, whose 'savage' pictures are always faintly reminiscent of tourist advertisements.

It was not only the painters of the Brücke group, to which Nolde, Pechstein and doubtless Mueller too belonged, but also those of the Blaue Reiter group who looked for stimulus in primitive art. The almanac of the Blaue Reiter which had been published in 1912, contained reproductions of the most diverse works of primitive art; the choice of paintings, which had been made by Kandinsky and Marc, was clear proof of a deep interest in primitive art, but not on account of its magic aspect, which is what had attracted the Brücke group. While the latter were basically concerned with the magic side of African and South Sea Island art, the painters of the Blaue Reiter traced their steps back to the naiveté of Bavarian folk art.

The consequence of two differing conceptions becomes clear if one compares the delicate and almost lyrical primitiveness of a Campendonck or a Klee with the very credible magic that emanates from the paintings of a Nolde, a Kirchner or a Schmidt-Rottluff.

Kandinsky expressed very clearly what the Blaue Reiter painters were looking for in primitive cultures: 'A similarity in the moral and spiritual orientation of an entire era; the pursuit of goals which had been largely forgotten, and the affinity with one's inner climate, an affinity that can logically lead us to use forms that have served the same purposes successfully in the past. In this way our sympathy for and our comprehension of the primitives grew; as did their attraction for us which we discovered for ourselves. Just as we do, these uncorrupted artists concentrated purely on the inner substance of their works, thus automatically renouncing all external similarities'.

Bernard Meyers believes that, as a result of rational reflection, the Blaue Reiter artist felt the need above all to search for forms of expression that come from other eras and other cultures, and which coincided with their own way of thinking and feeling. The predilection of the Brücke painters for the primitives was much more spontaneous, although they were also reflective.

It was probably the Blaue Reiter artist who first considered children's drawings as an important source of inspiration and put them on the same level as primitive art. This is most evident in the work of Klee. What astonishes Meyers in the painters of the Blaue Reiter group is their ability to empathize with things, whereas the Brücke group tried to use the forms of primitive art spontaneously and to pour out their own emotions into nature. The position of the Blaue Reiter painters is much more intellectual – according to the comparison that Kandinsky made between the functions of a modern painter and those of a primitive one – and it encourages the painter to identify completely with his original sources. Nolde, Pechstein and Otto Mueller received greater or lesser stimuli from the primitive civilizations they encountered on their travels. Their personal identity, however, always remained intact (as in Gauguin). An artist in the Blaue Reiter circle like Campendonck, on the other hand, tried to think like a primitive or innocent being. He was not concerned with adopting the outward forms of an art because of its healing powers or in using it to heighten a sensation. He was interested in identifying himself totally with primitive man. This process took place on other levels too. Klee, for example, tried to transpose himself into the world of a child, and even to understand the mentally ill. Marc endeavoured to experience animals' impulses. In each case the artist probes the soul of the 'natural' and untainted creature in order to translate its behaviour into his works.

Meyers concluded that in retrospect the quest of the Blaue Reiter group seems to be the logical result of an evolutionary process; it began possibly with Gauguin whose rather intellectual first explorations were deepened thanks to the Fauves: they deliberately tried to give a spirituality to their pictures by using distorted shapes and unnatural colours. This tendency went so far in the paintings of the Brücke that real shapes and colours were sacrificed without any qualms. Their aim was the complete fusion of outline and background in order to increase the intensity and effectiveness of their meaning.

Thus it was that the Blaue Reiter painters achieved a complete identification with the primitive world. The artist abandoned his everyday existence to journey into a different sphere. The Brücke painters had upset the natural order so that they could see what was hidden behind the world of things. The artists of the Blaue Reiter group were absorbed into the mysterious universe of nature and were lost in it without sound or stir – astonished like a child, beside themselves like a madman, naive as a peasant, simultaneously nervous and joyful like an animal.

If we are here drawing on the earlier spiritual and intellectual forms of German expression, we should nevertheless ask ourselves whether Worringer was not right, when he saw an apocalyptic fear behind this trend in modern art, the fear of an art which questions itself. He considers this art to be lacking the metaphysical basis which primitive art still possessed in its magic and which could have supplied the modern art forms with a powerful originality of expression. Worringer did not fail to recognize the cause of this lack. He knew that a new movement such as Expressionism only emerges when art has already been torn from its social context; in other words, after the rift between the artist and his public. In this, Worringer is far in advance of Lévi-Strauss. Strauss was also to reach the conclusion that there was no longer any artistic commerce between the aesthetic sensibilities of the individual and those of society. Art, which had once been the most important agent of metaphysical forces, must content itself with being a pretty and interesting mark on the wall for people who occasionally seek aesthetic emotion.

Surrealism and the art of the South Sea Islands

One day André Breton said in Pierre Langlois' presence: 'African art is the earth, tilled land, motherhood. The art of the South Seas is a bird, the heaven, a dream'. This assertion is incorrect, because it is too absolute. On the one hand, one finds shapes in African art which are very close to those of the South Sea Islands: for example the sculptures of the Nalu tribes and those of New Ireland. On the other hand, the claim that African art is concerned exclusively with this world is fundamentally false. It is sufficient to read the pages that Elie Faure has devoted to African civilization to realize that this is an invention by Breton. Griaule's remarks about the cosmography of the Dogon tribe confirm what was in Faure largely intuition and supposition. It is, moreover, very understandable that the Surrealist should have preferred the art of the South Seas to that of Africa. Any attempt to define the position of the Surrealists recognizes in sleep 'the other self', 'the value of the true means to achieve knowledge' without which clarity would be obscured'.

'I dream, therefore I am' the Surrealist might say. In this sense, he does follow – if one may use this expression – the South Sea Islanders, who saw the dream as a major source of inspiration. While he works, the sculptor is subject to ideas that are intended to cut him off from the profane world, from a contact that he should maintain with the sacred; he thus risks harming his contacts with this world. It is symptomatic that the dream is regarded as one of the major sources of inspiration. The soul is encouraged to forsake the body during sleep and perhaps, in the course of its search for adventure, to penetrate into the world of the dead and the divine.

The Surrealists equated this world with the unconscious, whose unsuspected powers were uncovered in the works of Freud. Only the dream left all the privileges of freedom intact for man. Thanks to the dream, death lost its dark significance and the meaning of life altered. Surrealism opened the doors of the dream world to all those from whom night had concealed herself.

African art, which, according to Picasso, was essentially 'rational' (meaning that creative artists reveal what they know, and not simply what they see) was of scant interest to the Surrealists. Their position was more in accordance with the intellectual endeavour of the Cubists to translate their fragmentary vision of reality into an all-encompassing one.

The Surrealist, whose favourite tool in attaining the realm of the miraculous was the dream, valued precisely the dark side of South Sea Islands art; they were more sensitive to the emotive and magical elements of this art than to the classical values of African sculpture.

As the Surrealists grew tired of the structure of a civilization that they judged inadequate and even misguided, they strove to surround themselves with a wild aura and to emphasize their liking for the art of supposedly primitive peoples, whose powerful beauty was still close to religious and magical origins, and which was more successful than any other in repelling the forces of darkness.

This appeal to primitive art is a little surprising when one sees the styles that certain Surrealists adopted to convey their spiritual experiences. The modern art historian is forced to admit that form in Ernst, in Tanguy, in Brauner and in Dali is characterized by a search for precision. Their style shows umistakeable classical leanings. It might therefore be legitimate to conclude that the raptures of the Surrealists were above all intellectual: they were part and parcel of the artistic hell that followed the artistic paradise of the previous century.

But the sources on which Surrealism draws provide a choice between several possible styles: firstly there were the paintings born of dreams and frenzy, and realized in hallucinations; then, the paintings in which psychological automatism welled up from the depths of the unconscious; and, finally, the paintings born of a magical experience of things, an experience that releases us from the fetters of relationships in the concrete world. A tendency to situate phantasies very precisely in an illusory realm emerges from these diverse pictures produced by Surrealism. The painters mentioned above are the main representatives of this surrealistic verisimilitude. It would be very difficult to demonstrate a correspondence of any sort between them and primitive artists on the basis of their works.

But there is another tendency, that which has produced the paintings of Automatism. Both imitation and illusion are foreign to them. The canvas is the page on which the unconscious expresses itself in signs that make up an imaginary language. The surface of the canvas becomes a place for conjuring spirits. Juan Mirò is part of this movement. It is called 'absolute Surrealism'.

At the same time as Mirò was painting his pictures in a state of trance, the irrational, the contingent and the miraculous were beginning to appear. The act of seeing, which was a static accumulation of visible data, now gave rise to stirrings in a forgotten or suppressed consciousness. Mirò does not make a distinction between the real, the imaginary or the product of a hallucination. He follows the path of his inner emotions and gives them shape. Every line in his drawings is an allusion, freeing us from a rational interpretation and bringing us into harmony with the work of art: it leads us into a spiritual reality where the symbol is king.

Mirò's pictures are the symbolic expression of a spiritual process and spiritual knowledge. The logic behind the painting, the logic of associations, cannot be understood rationally. The dream background is represented by the shapes of flowers; a bird hovers above them, linking the realm of the unborn with the realm of the dead.

In Mirò's paintings we find again our childhood naiveté, unsullied and profoundly joyful, just as we rediscover the primitive power of the imagination. Because of these roots in an Orphic world he possesses a particular ability to recall, and seems spontaneously to have at his disposal, means of expression known to mystic cultures. Such an art will be closest to that of the primitives, and especially to the art of the South Sea Islands, whose wealth of forms appears to obey fantasy only; it leaves the artist more freedom than does African art. A theoretical basis could be found for this relationsip if it is true that plastic art, just like poetry and music, is innate in man. In other words, man is naturally an artist, he needs no formal training. The belief that, however simple a work of art may be, its origins lie in an inborn predisposition in man, and that artistic activity occurs for its own sake, is one of the two explanations offered for the significance of art in primitive societies. The other theory takes the

opposite view. It holds that primitive man is, above all, practical: when he paints an animal on the wall of a cave, this is not because he finds some kind of satisfaction in this activity, but because he believes that he will make this animal, which is his prey, more plentiful.

Although it could be added that both factors have played a part, we must take into consideration that the art of the South Sea Islands, as with all primitive peoples, was not a specific domain limited by well established boundaries within this culture. 'Art for Art's sake' was unknown in these societies. The art of these peoples served as a bond between the different spheres of life, and especially as a means of reconciliation with the supernatural world. Each work of art had a definite goal to attain, a vital function. The South Sea Islanders feared the spirits of the dead, the polymorphic demons, the omnipotent gods. They were seeking appeasement, help and deliverance when they created their works, Those that were the result of such a desire are with justice the most impressive and intense. It is here that we can see the dividing line between modern and primitive. On the one hand we have an art without obligations or ties, on the other an art which is used to implore and to appease. It is impossible to cross this boundary at will. Those who too often consciously look for 'the miraculous, the only source of a true bond between man' (André Breton) find instead only the absurd.

After the Second World War, Surrealism evolved in a way that seems to be the ultimate consequence of psychological automatism. This abstract Expressionism was in fact the logical move towards an art which regarded the exclusion of consciousness as the real condition of its existence. A painter like Dubuffet draws directly from the art of primitive peoples. He resolutely paints the repugnant and the absurd. In his paintings the primitive element appears in forms that are reminiscent of pictures by children. One wonders whether Dubuffet has in fact looked closely at primitive art, whether he was able to overcome certain preconceived ideas to which he clung. If he had really made a study of primitive art he would have seen that the primitive artist has a very precise conception of beauty, of form and of the effectiveness of form. When he points, he does so with established symbols which are familiar to him from tradition. The primitivism of a Dubuffet is the result of the unease he feels in contact with bourgeois civilization; for this reason alone it is false. If his art had some affinity with a specific type of primitivism, it was with drawings on a wall that are the expression of an entirely personal torment. Only a century that recognizes its own inhibitions in the pseudo-primitivism of a Dubuffet could take it into its head to compare these inarticulate products of a personal neurosis with the clear and precise speech of primitive art.

The encounter of European artists with the works of primitive cultures at the turn of this century was of crucial importance for the evolution of western art. The discovery of ancient, long forgotten civilizations through knowledge of, and contact with, the exotic was taken up by the moderns, who had had no links with traditional art since the Renaissance, with astonishing emotion, almost as if it were a revelation. Was this a means for them to combat the growing senselessness of their time and to rediscover a new and fundamental religious experience in a world that had long lost its religious foundation? Was there a possibility of attaining their goal, in their apparently hopeless search for a meaningful content, with the aid of primitive art, which was so different, bound as it was to its myths?

In the first flush of enthusiasm these artists believed that they could find themselves, once they had discovered the long buried origins of the divine world. In retrospect we must conclude that the moderns received endless stimulation from the primitives, but that they were scarcely able to penetrate to the metaphysical substructure of primitive art. A major part of this book is devoted to a comparison between the works of primitives and modern primitives. It

reveals that it was really only in form that the primitives were adopted. Only in exceptional cases did the moderns succeed in giving these forms a valid content. The cultural basis of the primitives was never entirely revealed to them because it inevitably remained essentially alien. But this encounter gave some artists the power and courage to discover hidden depths in themselves, and to give them expression.

LIST OF ILLUSTRATIONS

Marquesas Islands, Polynesia
Clubhead
Wood, 132 cm
Rautenstrauch – Joest Museum, Cologne
The Tiki motif, which is typical of the
Marquesas Islands, appears in several
variations on this clubhead. The ornamentation,
which has the appearance of chased work, is
set out with great care. A face with a wide
mouth is carved on the half-oval formed by the
bulge at the top; the shape of the eyes
corresponds to the motifs on the shaft, from
which lines radiate outwards. The upper part of
the clubhead resembles a face. The rather
elongated circles are drawn with delicate lines,
and the chunky heads in the centre again recall
eyes. A horizontal indentation with a broad
head resembling a nose separates the top from
the shaft of the club. The diversity of the
ornamentation reveals the work of a master.
Similar motifs are to be found in the tattoo
patterns of the natives. Although such clubs
were used for religious purposes, they were
nevertheless also carried in battle.

1a

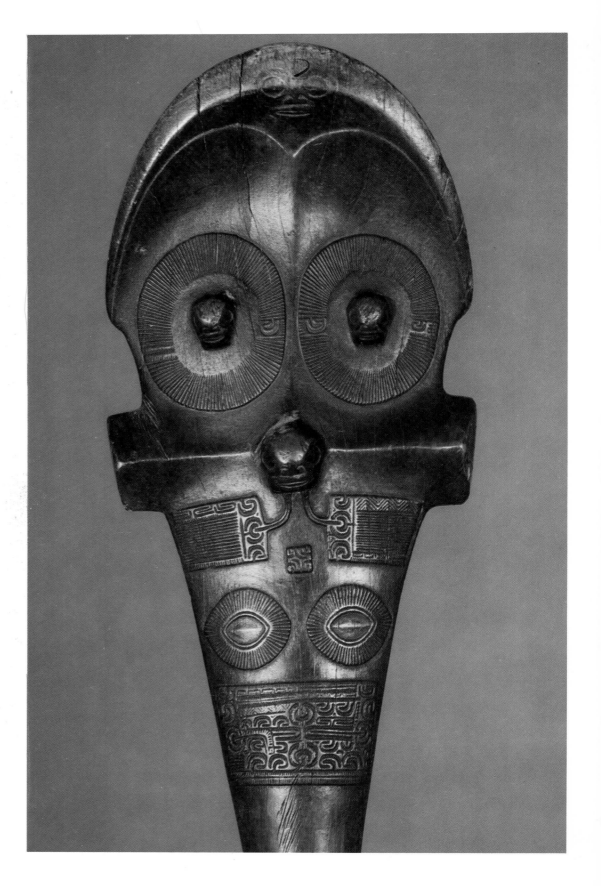

Paul Gauguin

Crucifixion

Woodcut, 40.5 × 13.5 cm

Wallraf-Richartz Museum, Cologne

Gauguin's love for the primitive and the exotic has been attributed to the Inca blood in his Peruvian mother. But since Bernardin de St-Pierre's novel *Paul et Virginie*, it had been traditional to seek salvation in unspoilt naiveté and the exoticism of primitive life. Gauguin realized that he could not find this happiness in France. He longed for the forests of a South Sea Island where he could 'live in ecstasy and tranquillity'. In 1891 he went to Tahiti. However, he soon expressed a desire to settle in the Marquesas islands 'where there are only three Europeans, and the South Sea Islander is much less spoilt by European civilization'. According to Herbert Read, Gauguin's flight was a reaction against the industrial revolution which was mutilating the face of the earth. For Gauguin, European civilization was a quagmire, from which he could only escape by fleeing. He drew inspiration from the art of the South Sea Islanders. This woodcut is modelled on the clubhead from the Marquesas pictured here. But Gauguin was eclectic, and remained bound to tradition. He adopted the dominant motif of the club, reproduced the shape of the eyes, and turned the pupils into small heads. However, the religious world which had determined the art forms of the Marquesas remained alien to him. He had recourse to the crucified Christ, an element which appears quite absurd here. He used the formal elements of primitive art, but the different nature of its religious background meant that it was inaccessible to him.

1b

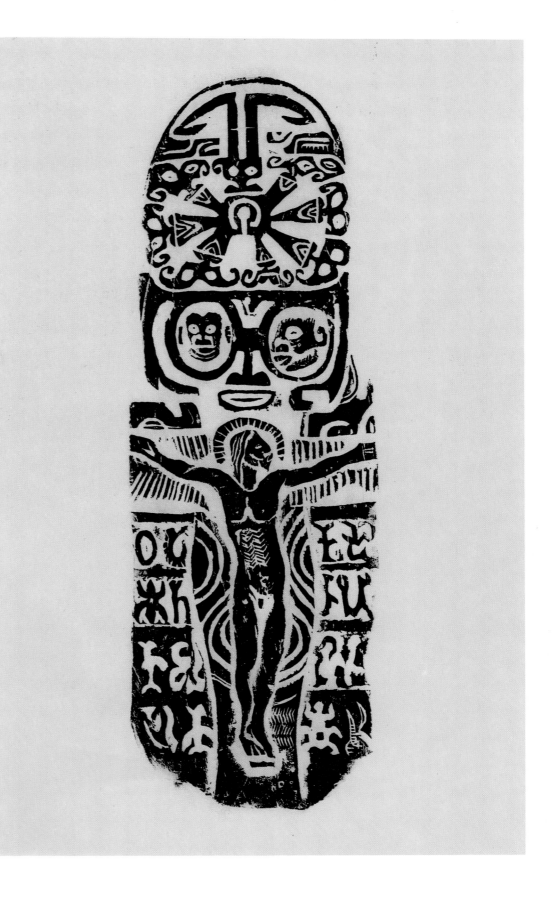

Cap Dorset, Baffinland (Eskimo Art)
Shoovagar
James Houston Collection
Man with a lamp
Stone
Photo: L Boltin

Contemporary Eskimo art deserves to be appreciated as an art form in its own right. It has expressive force, as this completely self contained figure demonstrates. It makes use of the characteristic elements in prehistoric Eskimo art, which goes back as far as 2000 BC. Today, as in past ages, it is vital to the survival of this hunting and fishing people that they should understand a situation, or an object, quickly and clearly. They carve walrus tusks, stone, or wood into animals, men and masks. The rich linear ornamentation of their tools – harpoons, axes, needle boxes, dice was augmented by spiral motifs reminiscent of Scythian or Siberian decoration. Paintings are very rare in Eskimo culture; they are found on the drums of medicine men. Their sculptures give an impression of solidity and power. They are not simply impressionistic depictions. They are concentrated on a centre of gravity. Body and limbs create an unbroken unity. It is not movement or dramatic action, but tranquillity and a sense of being, that radiate from the rounded, dignified contours of the man with the lamp. Barlach curbed his inner turmoil to produce a similar art form. The correspondence with Eskimo art is not coincidence.

2a

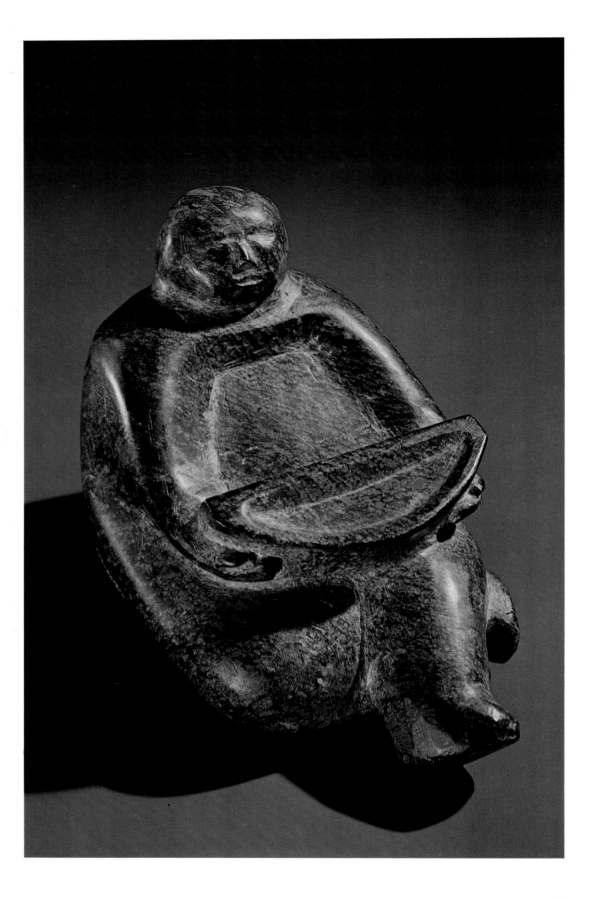

Ernst Barlach
Russian Beggar Woman, 1906
Hermann F. Reemtsma Collection, Hamburg
Ernst Barlach (1870–1938), the North German
sculptor, artist and poet, studied in Hamburg,
Dresden and Paris. Between 1901 and 1904 he
evolved his own style, making pottery of simple
forms, adapted to his materials. It was not until
he was thirty-six that he found the medium
most suited to him – sculpture – after a visit to
Russia, during which he discovered new
subject matter. He broke away from the French
and German tradition and his style became
unmistakable. His figures are seized by
metaphysical longing. Physically they are
imprisoned in their heavy, rounded shapes;
only their spirits struggle to be free. Barlach is
diametrically opposed to the individualism of
the nineteenth century. His figures transcend
personal limitations; their sufferings are the
sufferings of mankind – hunger, cold, old age,
poverty. His archetypal style develops into an
austere anonymity containing a secret religious
symbolism. This spirit emanates from the
Russian Beggar Woman. It is evident where the
relationship with primitive art lies; in the
figure's universality, in its stylization, whose
origins go far back, and in the way
transcendental forces are symbolized. While
Barlach was strongly influenced by the late
Gothic of North Germany, he has no
relationship with African art. His ponderous,
earthbound figures express an elemental
feeling. They are intimately connected with folk
art. In this North German sculptor we can
discover parallels with the primitive artists of
the north, the Eskimos.

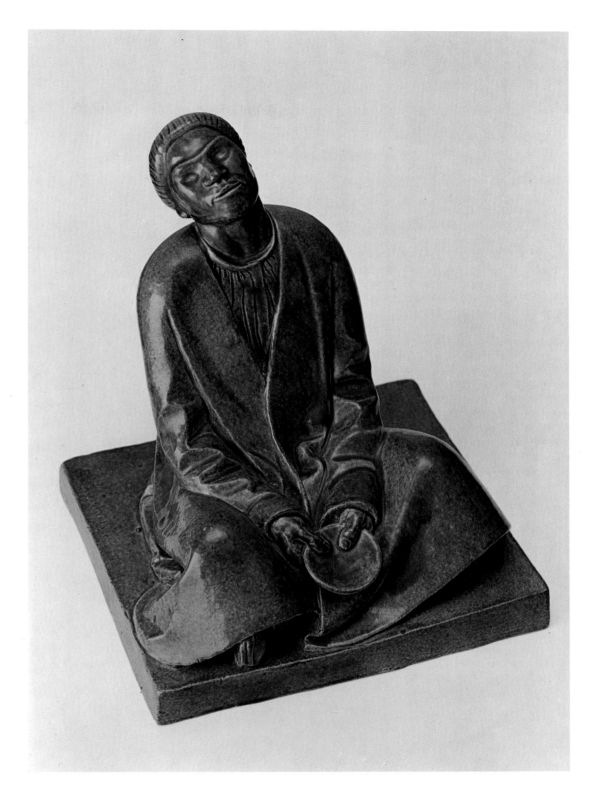

Ba-lega, Zaire
(Territory between the lake of Kivu and Tanzania)
Previously known as Rega or Warega
Figure with male head
Ivory
Charles Wentinck Collection
The small figures of the Lega tribe, carved in
ivory or bone, have a ritual significance. It is
not clear what this precisely consists of, but it
is connected with the initiation and admission
ceremonies for young tribesmen. A distinctive
feature of Ba-lega art is its formal conception
of the human head. Its structure is dominated
by a concave form, i.e. a forward curve is not
expressed simply by copying its natural curved
shape, but by deep incision. Henry Moore and
Picasso were principally responsible for
introducing this technique, which also occurs
in other African tribes (for example in some of
the Fang masks), into modern art. It can first be
seen in Picasso in 1907 when he painted *Les
Demoiselles d'Avignon*.
His many preliminary studies for this picture
had already borne witness to this innovation in
European art. Picasso is in harmony with anti-
realist African art. A head or a figure are
represented not by imitating visible shapes, but
purely through sculptural means. This means
that the sculpture obeys laws other than the
representation of nature. Whether Picasso is
here using analogy, or imitation, remains
undecided.

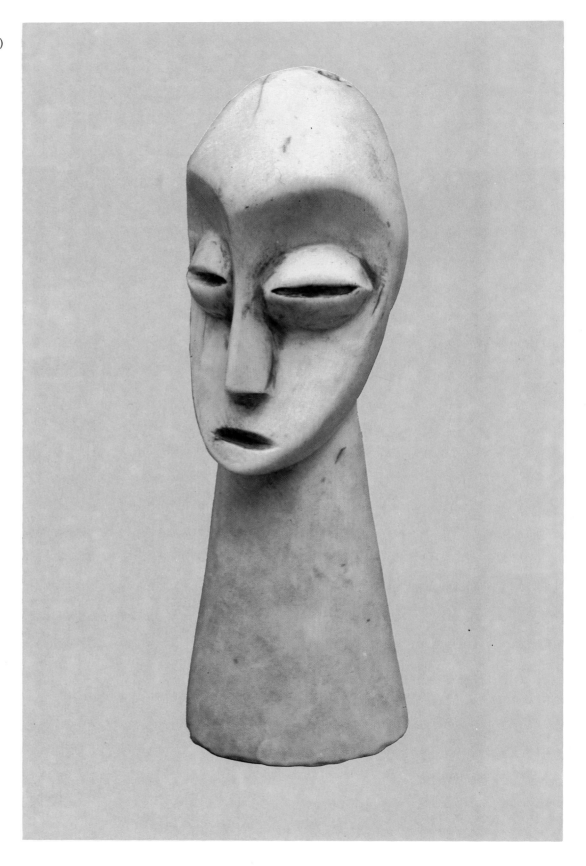

Pablo Picasso
Head of human figure, c. 1906
Douglas Cooper Collection
The structural kinship between the Ba-lega
head and this one by Picasso is obvious. It is as
far-reaching as that between the well-known
Babangi mask in the Museum of Modern Art in
New York, and the two heads on the right
hand side of Picasso's *Les Demoiselles
d'Avignon*, a painting dating from the same
period as the picture reproduced here. It had
already become evident that Picasso had been
greatly concerned with African sculpture in his
drawing of a mask from the Congo. This sketch
is contemporary to the preliminary drawings for
Les Demoiselles. Gómez de la Serna tells us
that Picasso had set up African and South Sea
Island idols in his studio at the 'Bateau Lavoir'
Despite his efforts to prove the contrary, there
can be no doubt that around 1907 African
sculpture had a marked influence on Picasso's
stylistic development. Robert Goldwater is
convinced that the different nature of the
figures on the left and right sides of the
Demoiselles can be traced back to the
influence of African art.

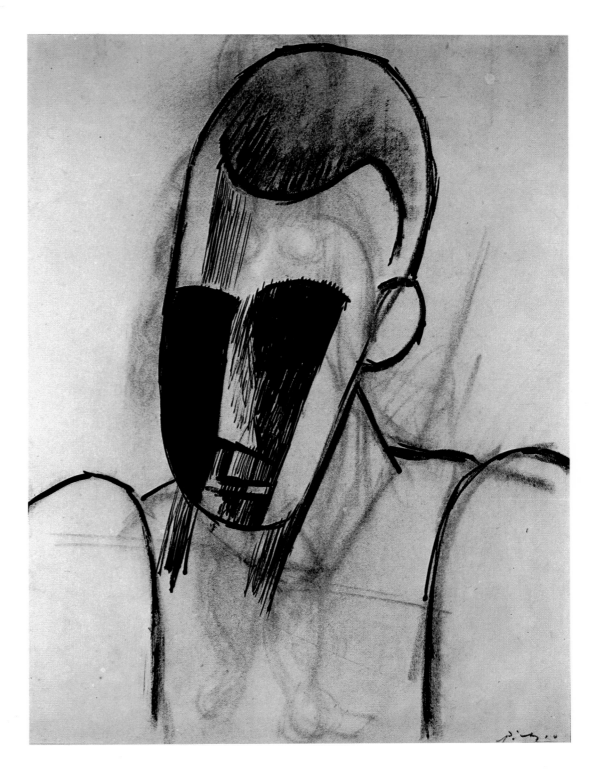

3b

Luba, South East Congo
Chief's seat with caryatid
Wood, 54 cm
Jacques Kerchache Collection, Paris
The Luba tribe belongs to the Baluba, the
largest culturally related group in the Congo.
Flowing lines, rounded shapes and great power
of expression characterize their art. The body
surface is handled with great delicacy. The
figure of a woman supporting the stool
represents the mythical mother of the tribe. The
Lubas have a matriarchal society. The ancestral
mother is the most important figure among
their forefathers. Modigliani adopted the
sharply delineated features, the sloe eyes
characteristic of Luba art, and the narrow
bridge of the nose. Although he has altered the
stance of the body, he has retained the
supporting gesture of the arms.

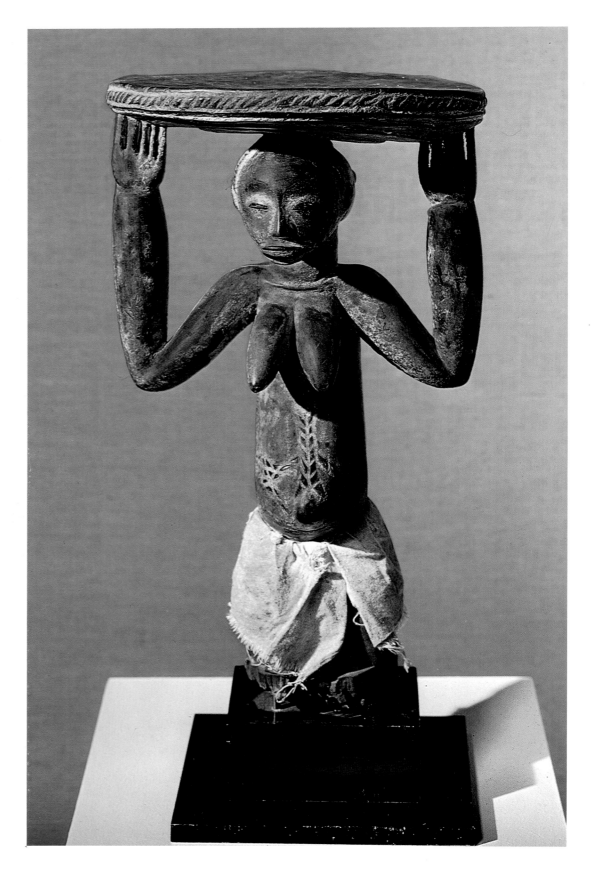

4a

Amadeo Modigliani
Caryatid, 1910
Painting, 72.5 × 50 cm
Art collection of Northern Rhineland and
Westphalia, Düsseldorf

Modigliani saw African sculptures for the first
time in Brancusi's studio. Shortly afterwards he
encountered them in the collection of Dr.
Alexandre, who was one of the first buyers of
his works. Although Modigliani changed his
style under their influence, he remained in
essence true to himself. The rigidity and
frequently violent distortions that Picasso
assimilated from African art were alien to
Modigliani. He himself rejected abstract art in
the sense understood by the Cubists. His art
never followed their principles. The elemental
aspect of the primitives lay outside his scope,
but he retained his feeling for a plastic
completeness of form. Under the influence of
African art the composition of his pictures was
simplified and made monumental, but without
sacrificing elegance. For Modigliani, simplicity
and subtlety were never mutually exclusive, nor
were monumentality and refinement.
Characteristically, he was most influenced by
the art of the Baule tribe on the Ivory Coast,
and the Luba people in what was then the
Belgian Congo. The Baule and related Yaure
tribes shared his sophistication. The caryatids
of the Lubas inspired Modigliani's studies in
oils and water colours on the same theme. The
female figure which supports the chief of the
Luba tribe's seat has the same free movement,
the same clarity of feature and the same
harmony of composition.

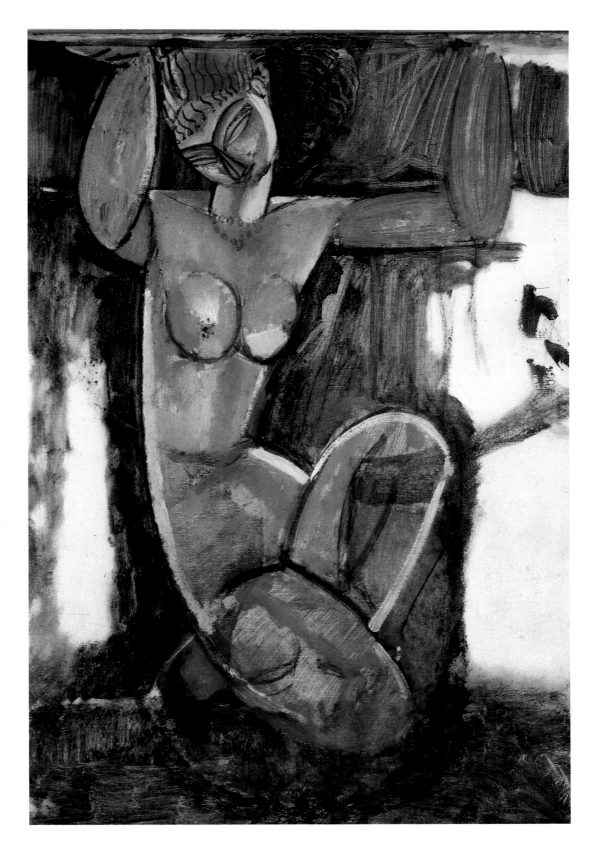

4b

Yoruba, Nigeria
Head
Wood carving, height 52 cm
Private Collection, Melbourne
The female head by Picasso dating from his
Cubist period, and the sculpture of the Yorubas
are obviously related. What caught the
attention of the artists at the beginning of the
20th century was the apparent freedom in the
handling of form. The primitive artist gave his
sculptures a structure that did not imitate what
he perceived visually, but which obeyed other
laws. The modern artists were largely
unconcerned with what these were; they were
interested in the arbitrary distortions and the
reconstruction of component elements with a
freedom which yet had sculptural validity. The
Yoruba head appears to be constructed
according to rules similar to those of the
Cubists. Analytic Cubism, such as the female
head by Picasso shown here, is born of an
aesthetic intention, which is not present
however, in Yoruba art. Admittedly it alters
nature, as does Cubism, in order to emphasize
the essence perceived by the artists, but it is to
create a transcendent reality, based on an
inherited religious feeling.

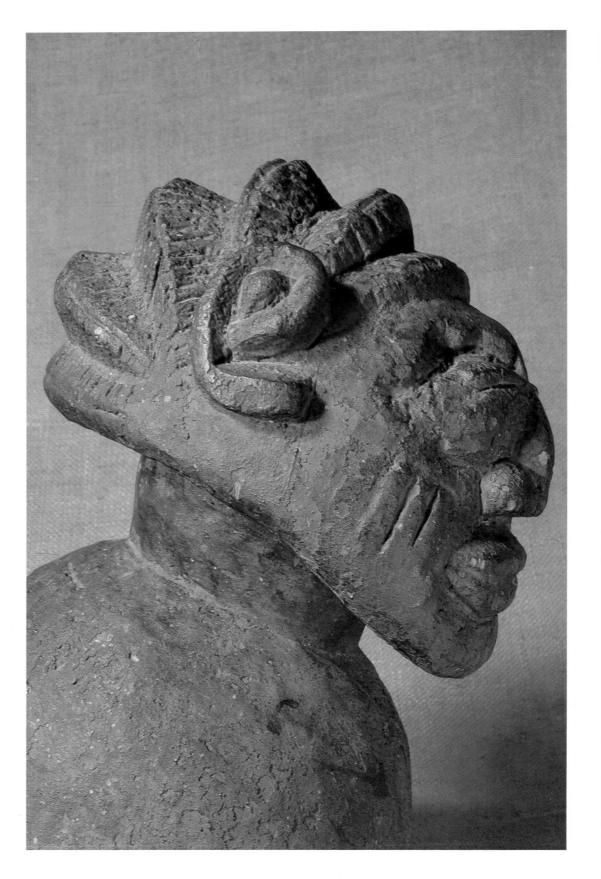

Pablo Picasso
Female head, 1910
Bronze, height 42 cms
Municipal Gallery, Zürich
In Picasso, the clear lines of the face, still
completely naturalistic – the prominent nose,
the rather full-lipped mouth and the easily
recognizable eye – are surrounded by the
confusing extravagance of the head, which is
boldly abstract. The spectator is immediately
struck by the similarity – almost identity –
between Picasso's head and that of the Yoruba
beside it. This female head is counted amongst
the 'pictures from memory' by Picasso. The
artist is familiar with a particular object and
remembers later the shapes which have made
the deepest impression on him. The details
which he takes from reality are then arranged
using free association, and fused together. The
rhythm of the sculpture is more important than
any information about the image recollected by
the artist. The individual details of the real
world lose their naturalistic function and are
considered exclusively as structural elements.
Reality is wilfully distorted. Picasso does not
expect the spectator to re-assemble the
separate parts to suit his own interpretation. He
has already united them into a new and
concrete reality.

5b

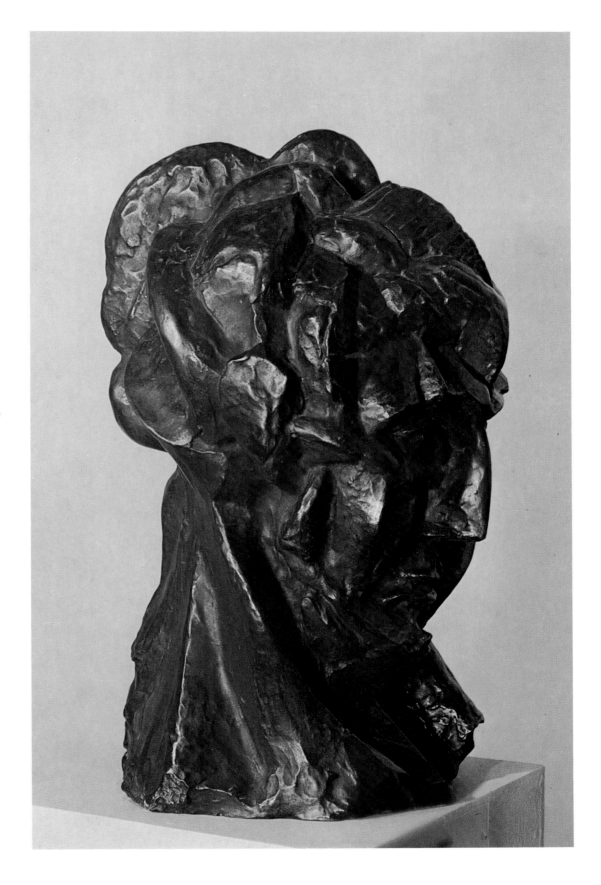

Baule, Ivory Coast
Ancestral figure
Wood, 25 cm
Charles Wentinck Collection, France
Although the naturalistic element predominates in this ancestral figure from the Baule tribe, the shape is still subject to the distortion typical of Baule art. What is not visible on this photo is the disproportion in the body shape. The head is almost as long as the very much shortened legs. Nearly all Baule sculptures have an abstract element which gives the face a distinctive expression. The stylized eyebrows and the sharp profile of the nose together create an archetypal unity. The oval of the face is exaggeratedly long; the hair is assigned an ornamental function. Yet, despite the stylization and a certain element of abstraction, this ancestral figure is suffused with a striking individuality.

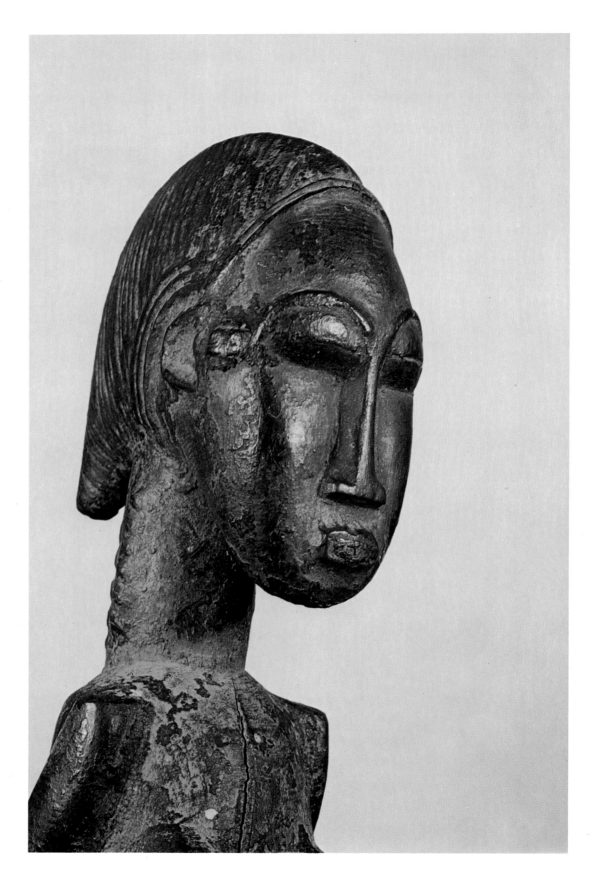

6a

Karl Schmidt-Rottluff
Girl from Kowno, 1918
Woodcut, 50 × 39 cm
Wallraff-Richartz Museum, Cologne
Karl Schmidt-Rottluff, who was born in 1884
in Rottluff near Chemnitz, was co-founder of
the Brücke group and was one of the leading
German Expressionists. By simplifying natural
shapes he created a personal style
characterized by monumentality. It is not easy
to say what influence the masks of the Baule
people (a negro tribe on the west Ivory Coast)
had on him when he cut *Girl from Kowno*. But
the nature of the girl's face reveals a substantial
correspondence with the clear, simplified
shapes of the Baule masks. Some of these
sculptures are considered to be among the best
works of African art. It is not important to
discover where the primitive origins of
Schmidt-Rottluff's methods of expression lie. It
is significant that the simplification of his forms
coincides with the primary artistic language
usual in the compositions of primitive peoples.
He adopts the negroes' ideas regarding form,
though only outwardly. For Schmidt-Rottluff
exoticism is simply a stylistic mode.

Yaure, Ivory Coast
Mask
Wood, 37 cm
Charles Wentinck Collection, France
The elegant and vigorous style of the Baule
tribe (Ivory Coast) has had a marked effect on
the sculptures of the Yaure people. The
modelling of their masks shows great
similarities; the differences lie only in their
stylistic emphasis. The sophistication in the
means of expression lend charm to the mask
shown here. Yaure sculptures have
characteristic closed, sloe eyes, set in an
elongated oval face; the emphasis on the
eyebrows and the clear outline of the nose
form horizontal and vertical elements. The
ornamental way in which the hair is handled
creates a very graceful effect. The art of the
Baule and Yaure tribes was easily appreciated
in Europe because it conformed to the classical
aesthetics of the West more than other African
tribes. France was particularly responsive to
their refinement and elegance.

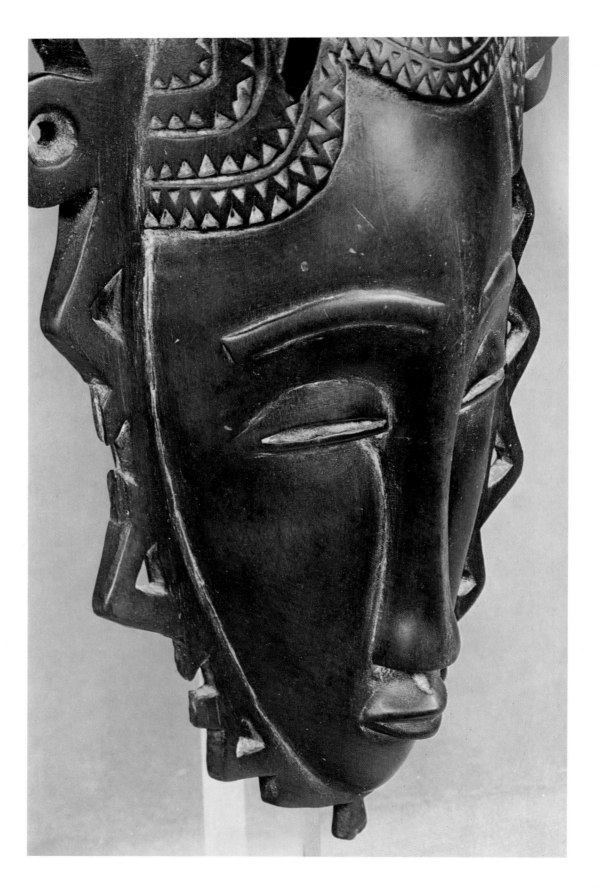

7a

Amadeo Modigliani
Head of a Woman, 1912
Musée National d'Art Moderne, Paris
The resemblance between the sculptures of
Modigliani's Cubist period and those of most
of the Cubists can be traced back to the
influence of primitive African art. Encouraged
by Brancusi, Modigliani devoted himself almost
exclusively to sculpture in the years 1909 to
1914. The parallel interests of both artists are
readily visible in their works of these years.
Modigliani's sculptures bear a close
resemblance to the style of the Yaure and
Baule; sometimes he also draws on the greatly
simplified facial shapes of the white Fang
masks as well as the more realistic art of the
former tribes. It is also true of Modigliani that
he remains subjective in his encounter with
African art. He does not recognize how the
primitive peoples differ from him. He does not
achieve the objectivity of the Africans.
Frobenius' hypothesis that Europeans would
accept the different culture of the Africans has
either never, or only infrequently, been realized
in the work of European artists.

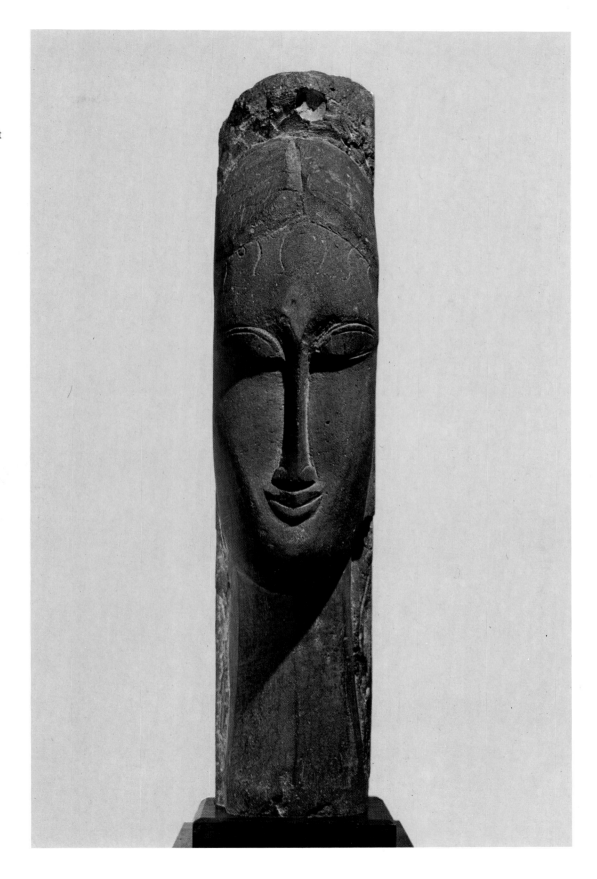

7b

Lukunor or Mortlock Islands, Micronesia
Dance Mask
Wood, 61.5 cm
Rautenstrauch-Joest Museum, Cologne
These whitewashed masks, known as
'Tapuanu', represent a benevolent spirit. They
decorated the houses where the men met. They
were used in beach dances, from which it was
assumed that they averted danger from a
typhoon and at the same time protected the
harvest of bread fruit. The formal conception of
the mask is the result of simplification. The
vertical line between the chin and the mouth
represents a bird; the nose is reduced to a thin
strip; the eyes consist of narrow slits, placed
close together. It is the forceful curve of the
eyebrows which gives the mask its arresting
expression.

8a

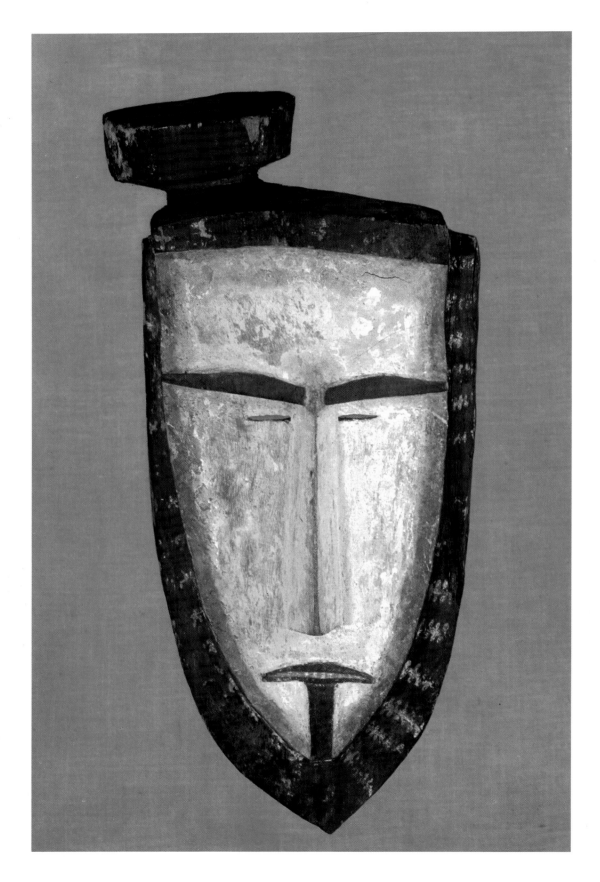

Alexej Jawlensky
Variations on a Human Face
Private collection
In about 1917 Jawlensky's painting underwent
a change. It is true that he continued to portray
the human face, but he endeavoured to free
himself from the individual features which had
dominated his paintings. He was trying to
transcend the individual and achieve 'the
universal human face' by eliminating all
personal traits. To this end he created models
which became increasingly more abstract. He
thus arrived at something like a portrait, but he
only retained the most primitive form of a
human face, reduced to horizontal and vertical
lines. The Russian Jawlensky was, moreover,
aiming more at a picture founded on religious
experience than at a portrait which was a
faithful reproduction of nature. He called his
variations 'enlightenment', 'inner vision' and
'meditation'. He wanted to depict not the type,
but the archetype. He may have used the
Mortlock mask opposite as a model. No one
knows whether he did encounter this example
of primitive art.

8b

Inca, Peru
Mask of a mummy
Museum of Art, Philadelphia
(Louise and Walter Arensberg Collection)
Photo: Alfred J. Wyatt
Klee tells us that he owed the inspiration for
the painting *Jörg*, shown opposite, to an
ancient peasant painting. But the affinity of
Jörg with an Inca mummy mask from a
completely different age and continent is
striking. It is tempting to seize on Jung's
attempt at explanation with the notion of the
'collective unconscious'. As long as Jung's
theory is not regarded as a scientifically
established fact, but used rather as a useful
working hypothesis, there can be no objection
to such an interpretation.

9a

Paul Klee
Jörg, 1924
Museum of Art, Philadelphia
(Louise and Walter Arensberg Collection)
Photo: Alfred J. Wyatt

Klee is aware of the fundamental difference between the art of the primitives and his own. He emphasises that the impression of primitiveness in his works can be explained by his attempt at simplification. He is exclusively concerned with achieving economy in his means of expression. This conscious reduction places him in direct contrast with the unselfconscious procedure of the primitive artist. *Jörg* originated in the desire to reduce form to fundamentals. Nevertheless it may be that the artistic process was unconsciously influenced by works of primitive art which he had once seen somewhere at some time. Just as words which we have once heard enrich our vocabulary, so chance impressions may bear fruit in the plastic arts. The word is admittedly linked to a definite meaning, while the image in modern art is intended to have an effect without explanation.

9b

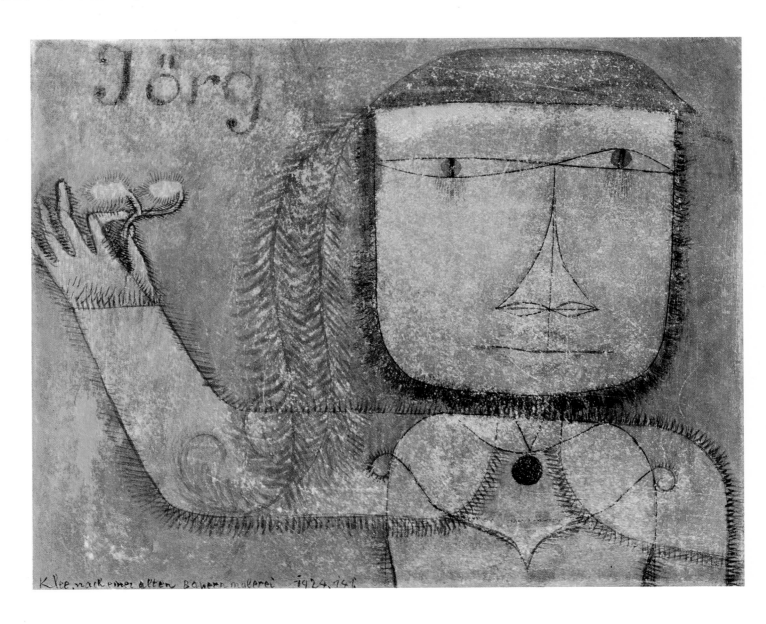

Nukuor, Caroline Islands, Micronesia
Figure of a God
Wood, 51 cm
Rautenstrauch – Joest Museum, Cologne
The wood figures which have evolved on the
small atoll Nukuor have a special place in the
art of Micronesia. There are hardly any other
figures to be found in the art of the South Sea
Islands which are so exceptionally abstract and
reduced to their essentials. The egg-shaped
head is not divided into mouth, nose, eyes or
ears. The body consists of the most basic of
structures. The arms hang from the heavy
shoulders without any articulation. The hands
placed on the hips are sketched in. There are
no distinctive sexual organs. The
disproportionately short legs merge straight
into the base, without any feet. Dr. Waldemar
Stohr, the curator of the museum where the
figure is displayed, has commented: 'The formal
correspondence between the Nukuor figures
and modern sculpture is often astonishing.'

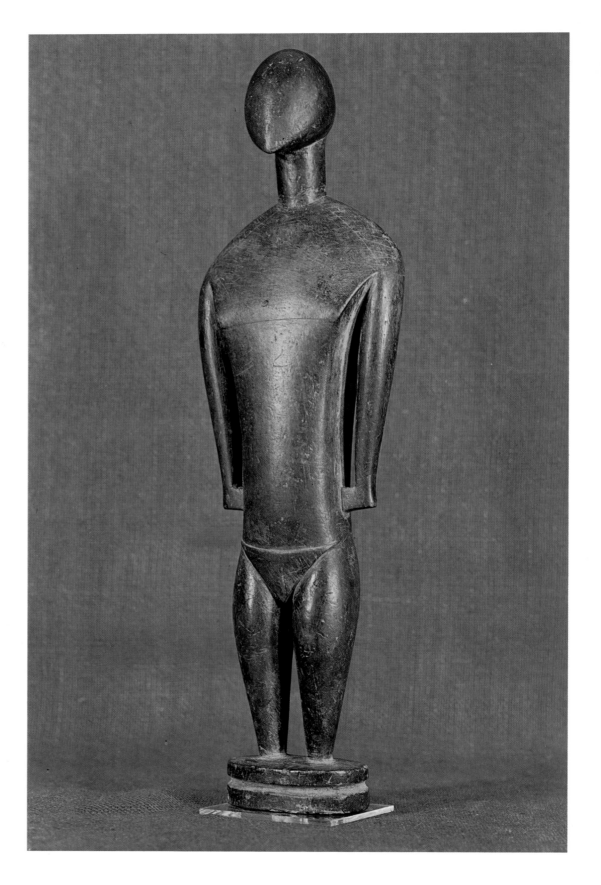

10a

Oskar Schlemmer

Two Girls, *c.* 1930

61 × 43 cm

Wallraf–Richartz Museum, Cologne

In his youth, Oskar Schlemmer (1888–1943)
was influenced by Cézanne, and later by Hans
von Marées and Georges Seurat. From 1920 to
1929 he was in charge of the sculpture section
and the theatre workshop in the Bauhaus of
Weimar and Dessau. In conversation with
Lothar Schreyer he hinted that he often had the
feeling of 'losing himself in mythical times'.
This he saw 'not as a loss, but rather as a
rediscovery, a return to his origins'. Schlemmer
went on: 'All my work in the Bauhaus is
concentrated on the human form, the first
image of man which contains all the potential
images of man in history, prehistory and history
to come. So I am now trying to construct the
human body from simple mathematical shapes
and the relationships between them. This basic
mathematical shape is simultaneously the
beginning and the conclusion of all bodily
forms'. Schreyer objected: 'Abstraction should
never be an end, but should always remain a
means of expressing the inner vision which
alone is the principle of the creative art. As
soon as abstraction becomes the external and
extrinsic reason for creating, no work of art will
result'. In reply Schlemmer explained why his
human figures, like those from Nukuor, have no
individual faces: 'Before we can, or ought to,
paint a face, we must perceive the type, the
impersonal. Everything that the most advanced
art of earlier times conveyed through the
human face, I would like to be able to say
secretly and cogently in the interaction of the
whole human body'.

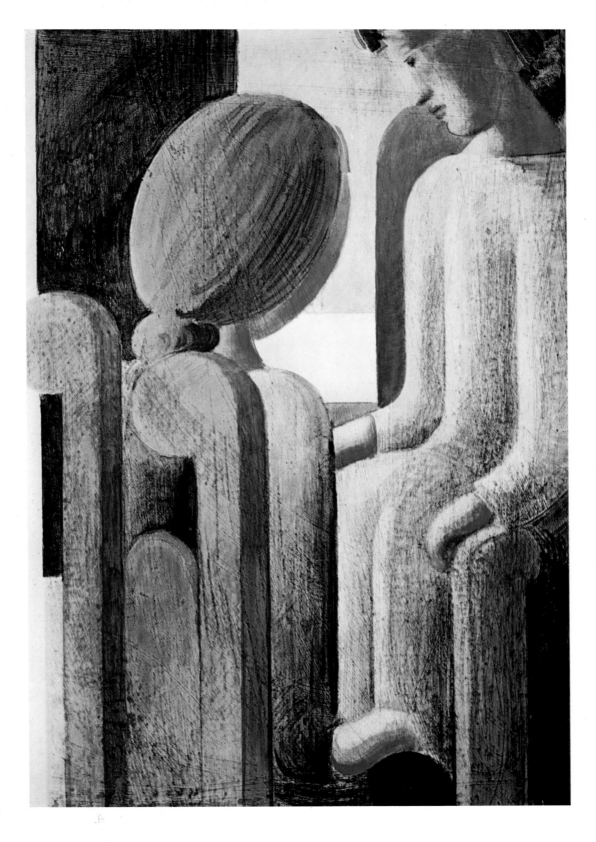

10b

New Ireland, Melanesia
Uli figure
Painted wood, 107 cm
Hoogstraate Collection, Amsterdam
The Uli figures are amongst the most striking
products of Melanesian art. They are
androgynous, usually drastically so. The
presence of female breasts and male phallus
indicates the ambivalent creative powers of the
primeval cosmic being. The Uli figures are the
incarnations of ancestors or chieftains. They
have a ritual purpose in secret ceremonies for
the dead, in which only men are allowed to
take part.

11a

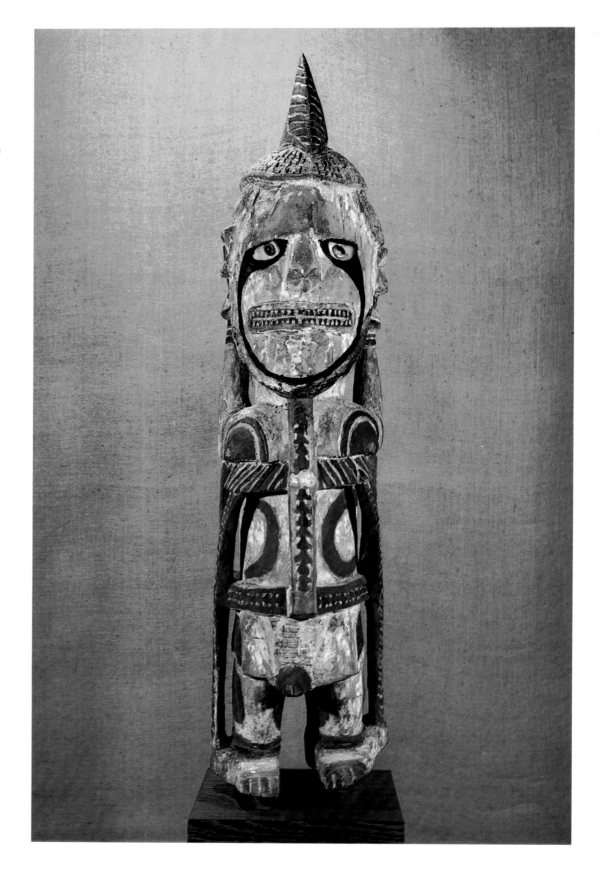

Emil Nolde (Emil Hansen)
Still life with a Uli figure, 1915
Oil painting
Nolde Institute, Seebüll

In his still-life Nolde has placed the omnipotent Uli beside two lovers who are turning towards each other: this is done humourously but with insight. The bisexuality of the Uli is split between the man and woman. Nolde does not introduce the Uli of the Melanesian people, symbolizing the original being of the creation of the universe, into his still-life merely as an imitation but as a conscious reference. On an ethnological expedition in 1913–14 Nolde reached New Guinea via Russia, China and Japan. It was from here that he brought back the Uli figure opposite. It belonged to an art collection, and he used it as a subject. Nolde writes in his memoirs how much the 'primeval' nature of primitive peoples fascinated him, and how great was his longing to get to know an unspoilt nature and native people. At the same time he was aware that the European artist under the influence of exotic models cannot alter his personal style without upsetting the distinctiveness of his language. On the other hand, he was attracted by primitive art because it had its roots in the depths of magic and the daemonic. Nolde, who deep down had religious instincts, was sensitive to such origins. Instead of reproducing reality, he depicted an inner image. The German Expressionist Nolde (1867–1956) always set himself apart. It is true that he belonged to the Brücke for a short while, but his shyness soon estranged him from all groups and turned him into a loner.

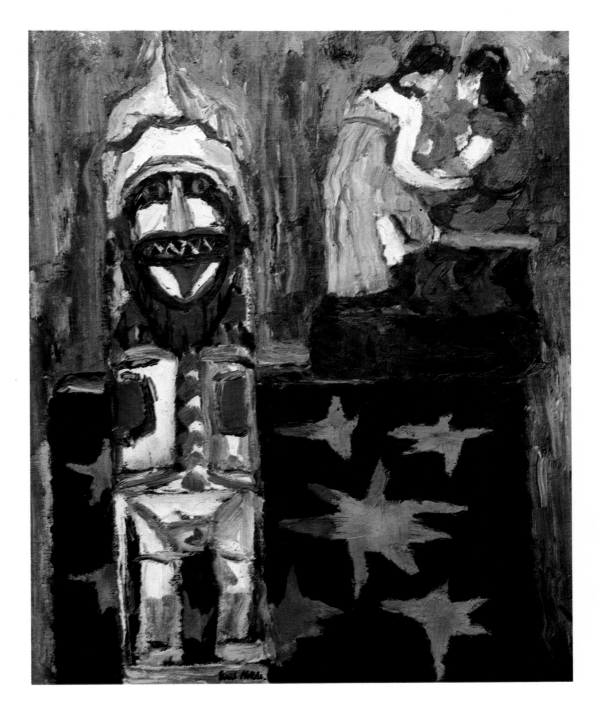

Cyclades Islands, *c.* 2500 BC
(found in the emporium at Calymnos)
Marble Head
15 cm
H. E. Smeets Collection, Holland
The marble idols of the Cyclades islands are the
beginnings of sculpture in the Aegean world.
In the simplicity and sobriety of their forms
they prove that a beginning can also be a
zenith. Most of the Cyclades idols depict the
nude female figure, sometimes reduced to the
shape of a violin. Some of them have heads
which are particularly schematic, they are not
much more than the basic shape with a vague
hint of a nose. The art of the Cyclades is based
on the search for pure proportions. A classical
form, born of a desire for simplicity, is at the
origin of Greek sculpture. Brancusi shows the
same simplicity in the sculpture opposite. He
too avoided details when not absolutely
necessary. He did not consider the sculptor's
task to be the reproduction of flesh, – or 'steak'
as he called it. In its conception, his torso of a
young girl corresponds completely to the head
from the Cyclades. The formal modelling of the
head or the body are the same. The fact that
the Cyclades idol originates in matriarchal rites,
while the motive behind Brancusi's torso is
aesthetic, does not effect their form.

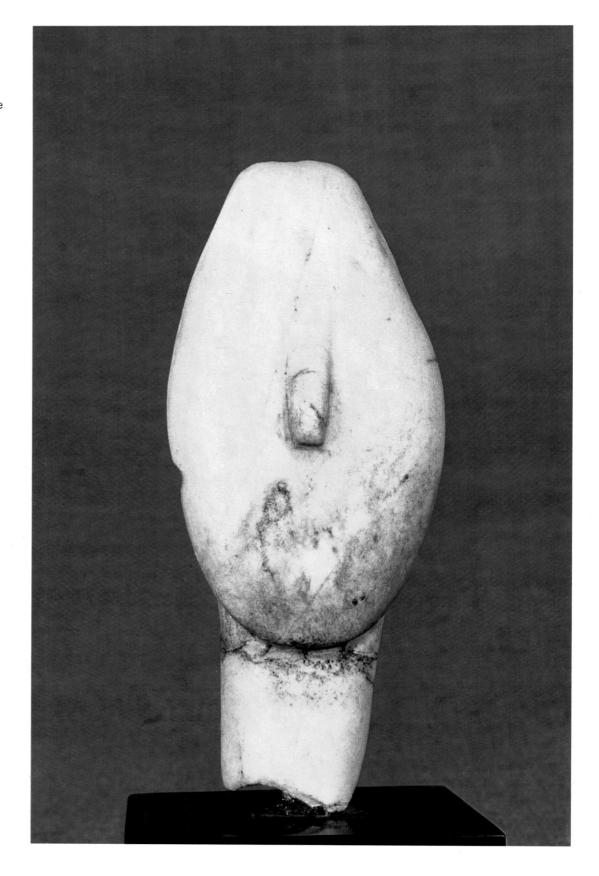

12a

Constantin Brancusi
Torso of a Young Girl, 1922
Marble
Museum of Art, Philadelphia
A. E. Gallatin Collection

The Franco-Rumanian sculptor Brancusi
(1876–1957) came to Paris in 1904 where he
worked with Rodin for a short while, but he
soon broke away from Impressionism and was
deeply influenced by ancient art. He succeeded
in fusing the exingences of his materials with
the demands made by the object to be
depicted. His fidelity to his materials set an
example for modern sculpture. His smoothly
polished works radiate tranquillity. Already at
the beginning of the 20th century Brancusi
was in opposition to the whole of European
sculpture since the Renaissance. His links with
an earlier art were proof of this. In the 1920's
the English sculptor Jacob Epstein had a
discussion with the curator of a museum, who
was outraged by Brancusi's works. Using an
Egyptian bird from about 3000 BC as an
example, Epstein proved that Brancusi's
extreme stylization and the lack of recognizable
features were not at all 'modern' but were, on
the contrary, to be found in the most ancient
civilizations. Brancusi knew that he was not
related to Rodin, but rather to millennial
traditions, such as those of the Egyptians or of
primitive peoples, which he had encountered at
an early stage. He was inwardly prepared for
the language of forms used by the primitives.
African art could only confirm what had long
been present in Brancusi. Many of his works
are irrefutable evidence of his encounter with
primitive art. The torso of a young girl
corresponds, in the principle behind its shape,
to the sober art of the Cyclades and its
reduction to bare essentials.

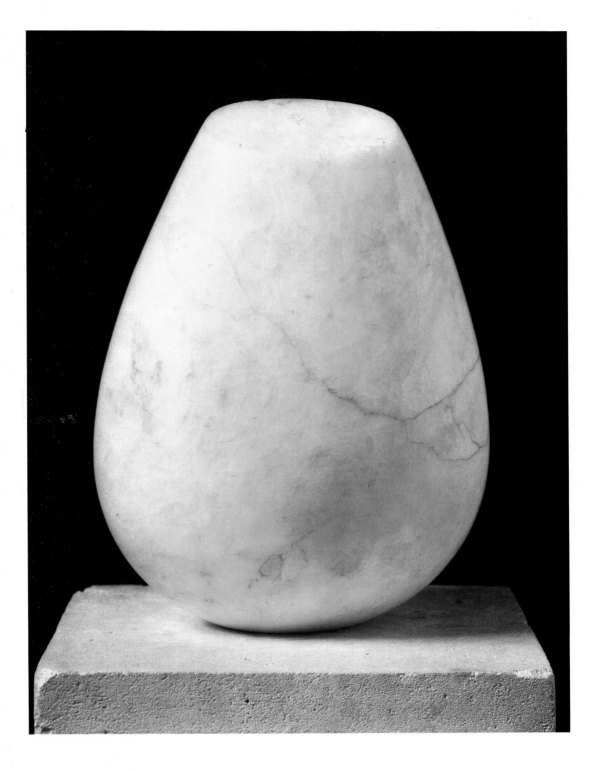

North West coast of America

Indian totem pole

Wood

Musée de l'Homme, Paris

Cut off from the rest of the continent by the Rocky Mountains, a salmon-fishing culture evolved along the shores of North America. It produced numerous art works, especially wood carvings. The inhabitants by tradition lived communally in large structures built of cedarwood and decorated with multi-coloured carvings. Each tribe has its own heraldic symbols, depicting mythical origins. Those who were aristocratic were proud of their rank and reputation. Tradition prescribed that they should invite others to the 'Potlatch', a celebration with much feasting. In proportion to their rank and wealth they openly displayed their riches and overwhelmed other tribes with precious gifts. This magnificent festival opened with the erection of a totem pole. These wooden poles were decorated with faces or the symbols of the tribe, but most frequently with representations of animals such as crows, bears, beavers, sharks or eagles.

13a

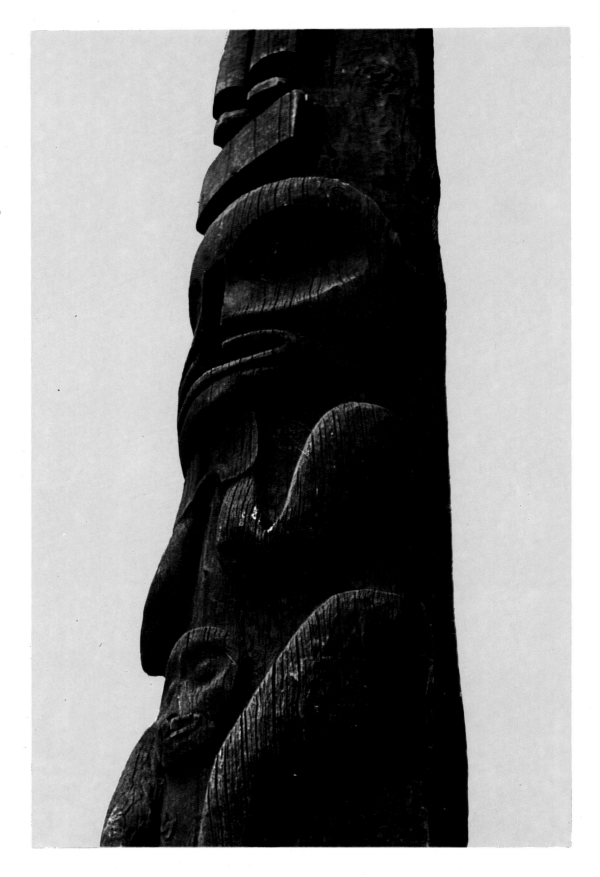

Jacques Lipchitz
Figure, 1926–30
Bronze
Museum of Modern Art, New York
Lipchitz, who was born in Lithuania in 1891, came to Paris in 1909. He joined the Cubists in about 1913. Initially, his sculptures showed a mathematical severity, and laid emphasis on the structural elements. They took their life from the formal rhythm which fused individual elements into a plastic whole. The actual composition constituted the subject; even where Lipchitz made use of abstraction, details in the shape remind us that the point of departure is in the visual world, as in the head of the figure depicted here. The human form did not derive its striking effect from naturalistic representation, but from the emphasis laid on certain fundamental components. This way of working brought Lipchitz close to primitive art. The relationship with the Indian totem is clear in this figure, while the concave form of the face is reminiscent of the copper figures by the Kota tribe (West Africa).

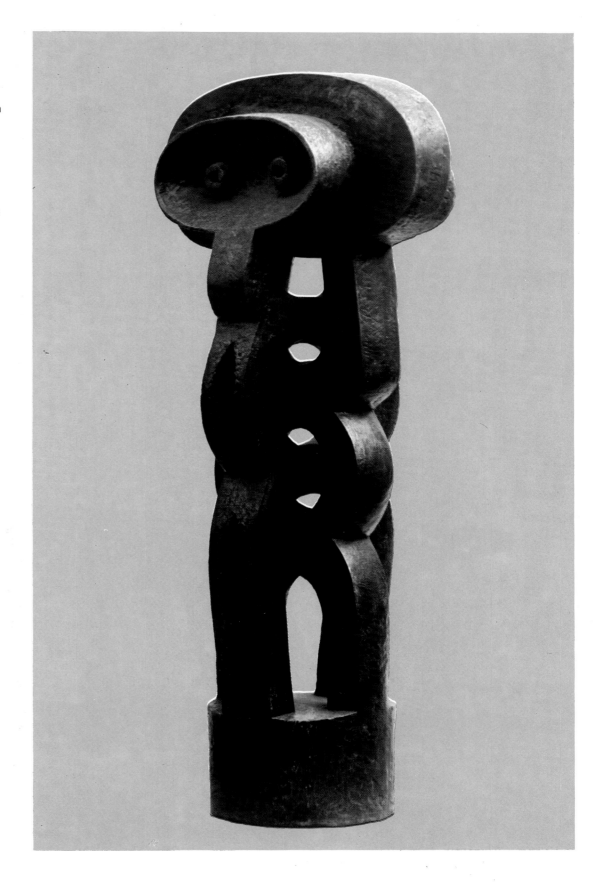

13b

Ashanti, Ghana (West Africa)
Akua'ba, Fertility idol
Wood, 34 cm
Charles Wentinck Collection, France

The Akua'ba is a fertility idol which is supposed to use its supernatural powers to help childless women conceive. When the Akua'ba has performed it function, it is given as a toy to small girls. Fetish priests regard the Akua'ba as a magical and religious object, with which they can conjure supernatural powers. After the 'incarnation', the idol is given to the woman petitioning for aid. She carries it in her shawl and treats it like a child to show the gods that she could be a good mother. What is noticeable about this figure is the round, flat head with a very high forehead. The eyebrows are heavily emphasised and are joined to the nose. The thin slender neck is made out of three to eight rings set on top of each other. The arms have no hands and stick out at right angles from the torso; the body is a simple, wooden cylinder on which rudimentary breasts and navel are carved. A connection has recently been established between it and the life symbol of the ancient Egyptians, the Ankh, from which the Akua'ba very probably evolved.

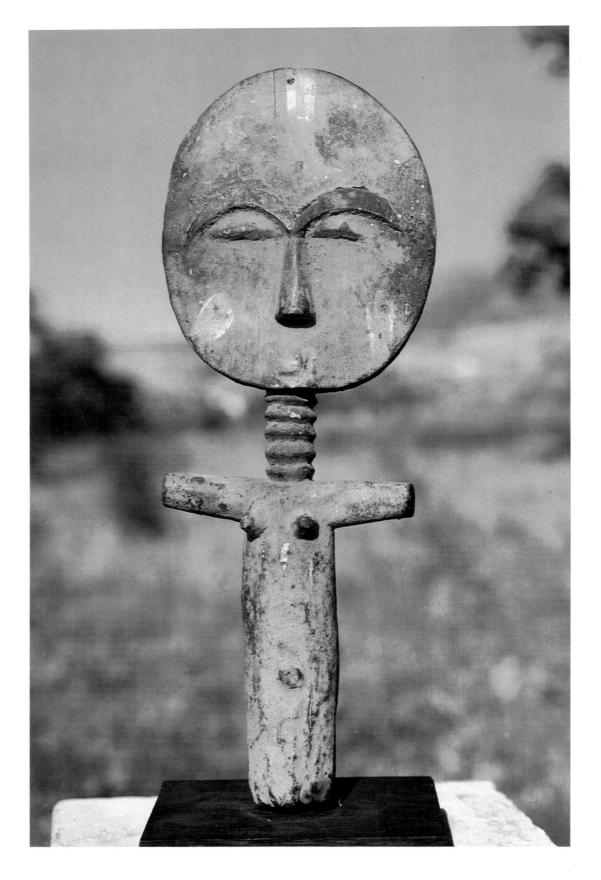

14a

Paul Klee
Senecio, 1922
40.5 × 38 cm
Public Art Collection, Basle
In Klee's art the visible and the invisible stand
side by side. His works are characterized by a
slightly melancholic cheerfulness, by an
enigmatic quality, a propitiatory daemon and
whimsical grace. The head shown here
confirms Klee's statement: 'Art is like the image
of creation. At any given time it is an
illustration, just as all earthly things are an
illustration of the universe'. The divisions of the
head, which is reduced to a flat disc, have a
rhythmic plan. The stylized eyebrows rise
above the narrow line of the nose. The notably
small mouth and the shape of the eyes bear an
obvious relationship to the Akua'ba. It remains
undecided whether Klee has deliberately
adopted its form or whether both images are
expressions of a universal experience. C. G.
Jung asks in this connection: 'Will we be
capable of accepting a newly created form,
which has grown in exotic soil, been watered
with foreign blood, spoken of in strange
tongues, nourished by strange civilizations, and
is part of an alien history?' Mythical symbols
like the Akua'ba are the primitive language of
the unconscious. Perhaps what Miró once said,
essentially with regard to himself, applies also
to Klee: 'For me, the unconscious is incarnated
above all by the art of ancient times. The living
forms produced by this art have evolved more
unselfconsciously; they are more free both in a
biological and in a spiritual sense. Thus the art
forms of earlier ages are purer than those that
followed. It is for this reason that they attract
me'.

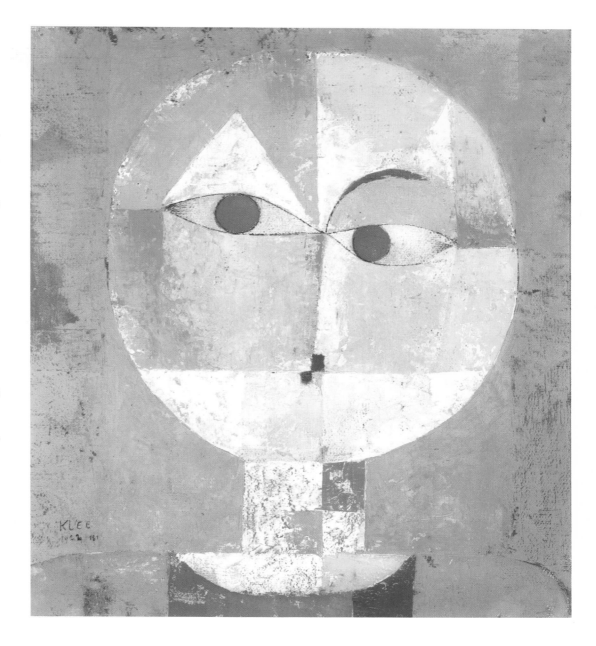

14b

Gabon, West Africa
Fang mask
Wood, 48 cm
Alice Derain Collection, Paris
The Fang people belonged to one of the most feared warrior and cannibal tribes of Africa. They live mainly in Gabon. The heads and figures, which they carved for use in worship, derive an exceptional beauty from the spirituality of their form and the modelling of their materials. Other Congo tribes, such as the Balumbo, use delicately featured, white-faced masks with a certain primitive quality for the worship of their ancestors. The mask depicted here was among the first pieces of African art bought by Vlaminck in a Parisian bistro. It made a deep impression on him. He wrote in his memoirs: 'I hung the mask over my head. It both fascinated and perplexed me. It brought negro art home to me in all it primitiveness and nobility. When Derain came to visit, he was struck dumb at the sight of it.' Shortly afterwards Derain bought the mask from Vlaminck and hung it in his studio. Vlaminck goes on to tell us: 'When Picasso and Matisse saw the mask at Derain's they too were overwhelmed.'

15a

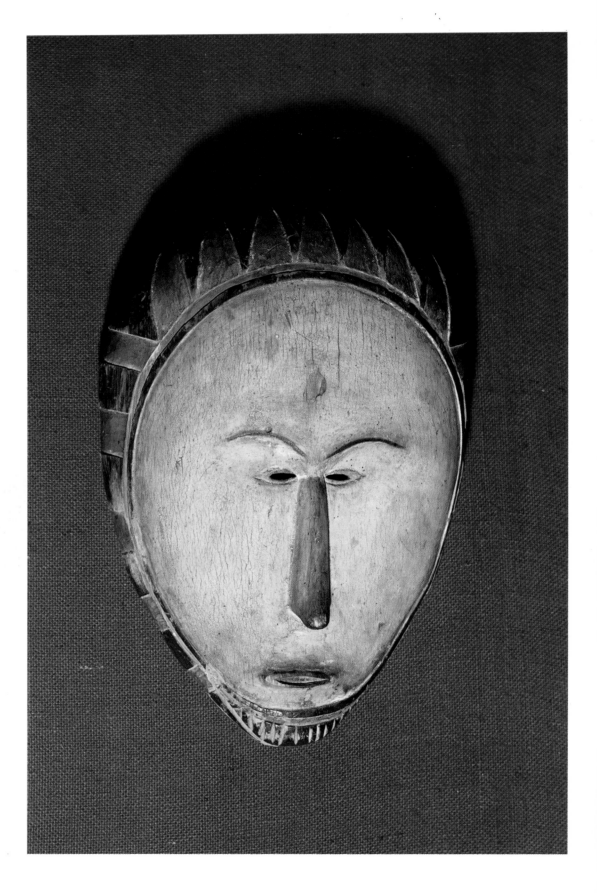

Julio Gonzalez

Japanese Mask

Dr and Mrs Arthur Lejwa Collection, New York
Gonzalez, who was born in Barcelona in 1876,
went to Paris in 1900 and made friends with
Picasso and Brancusi. Through their circle he
came into contact with African sculpture. At
the turn of the century Picasso and Brancusi
were acquiring works of primitive art for their
collections. The Fang mask opposite belonged
to Derain. It influenced not only the works of
Picasso, Derain, Matisse and Vlaminck, but
made a deep impression on Gonzalez. The
structure of his *Japanese Mask* obeys the same
basic laws of composition as the Fang masks.
The face is reduced to the same simple and
schematic rudimentary form. Circles and
vertical lines constitute the main formal
elements, the circles being modified into an
oval. In Gonzalez, expression attains primeval
force.

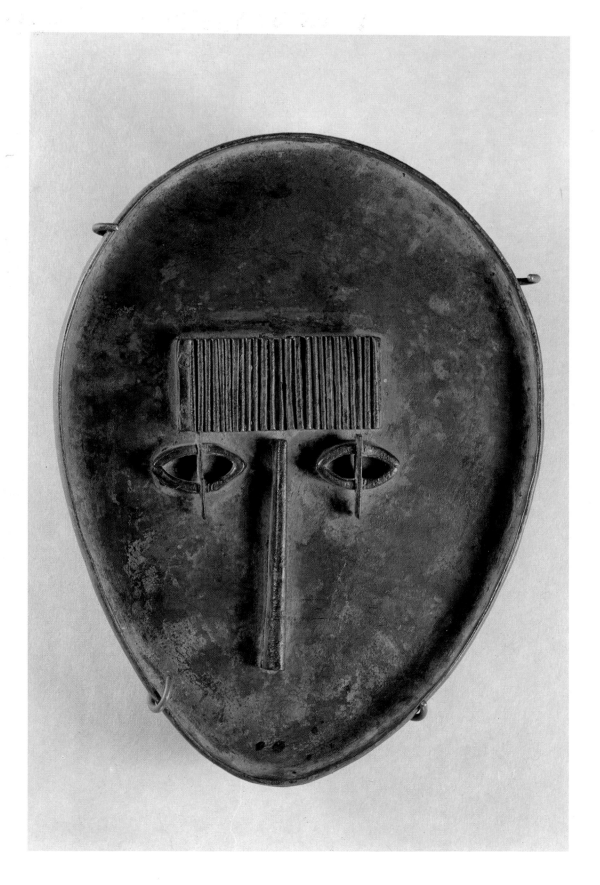

15b

Congo, (Angola)
Statue from a tomb
Soapstone, 38.7 cm
Musées Royaux d'Art et d' Histoire, Brussels
When the kingdom of the Congo first came
into contact with Portuguese explorers in
1482, it was already at a high point in its
culture. The statue shown here dates from this
period. The figure, which is sitting, has the
right leg drawn up. It has been supposed that
such sculptures represented the king or persons
of high rank. They were found in 'sacred
graveyards' dug in the earth. They were both
tomb and memorial stones representing
personifications of the dead person. The living
offered them sacrifices to propitiate the spirits
of the dead and to place the king and state
under their august protection. Manfred
Schneckenberger considers it possible that the
erection of gravestones can be traced to
European influences. He regards the gesture of
grief – the head resting on the hand – as an
indication of this, but no proof for his
hypothesis has yet been produced.

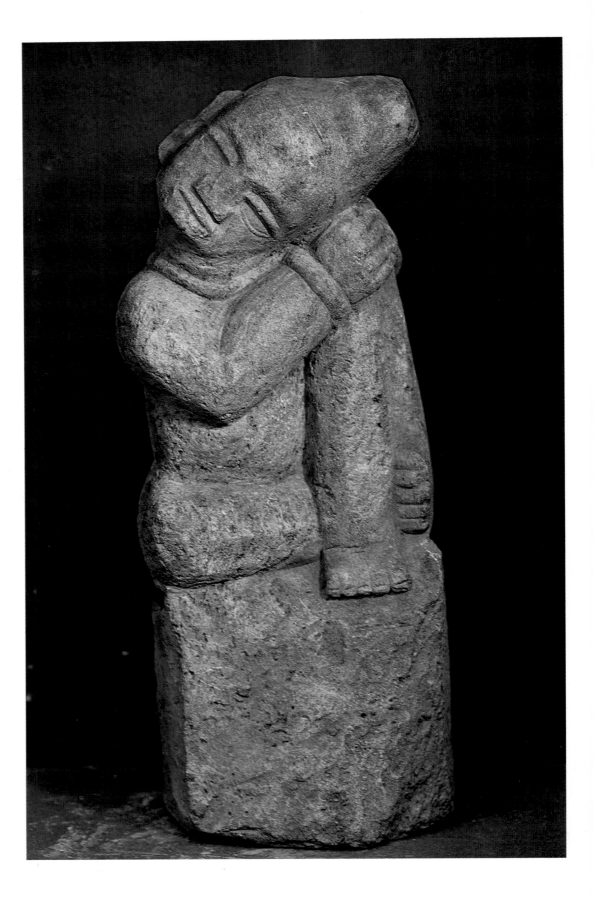

Ossip Zadkine
Seated Woman, 1928
Bronze, 79 × 32 cm
Schmit Gallery, Paris
Zadkine, who was born in Smolensk in 1890, joined the Cubists in Paris. He caused a sensation with his monument for Rotterdam, which had been bombed by the Germans. His best works were produced during his Cubist period. For him, the subject matter was merely a point of departure for discoveries about form which he united into a rhythmic composition. His *Seated Woman* has obvious Cubist characteristics. In its geometrical divisions the head is more like that of a bird than of a woman. The powerful arm and tightly gripped hand, as well as the foot, have naturalistic echoes. There is a relationship with the Congo tombstone both in form and content.

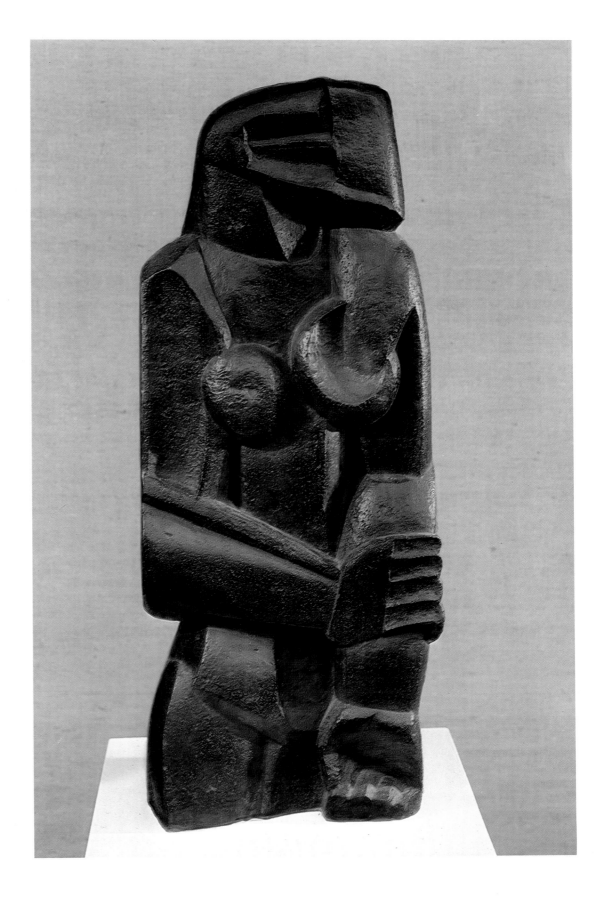

Mycenae, 1600 BC
Gold mask, known as the Mask of Agamennon
31.5 cm
National Museum, Athens
While no important finds have been made in
the beehive tombs at Mycenae, the shaft graves
contained a wealth of valuable weapons,
jewellery and vessels of precious metal. It is
clear that members of the royal family were
buried there together. The women were
adorned with gold diadems; the faces of the
men were often covered with a gold mask.
Sometimes these masks were only schematic,
sometimes they had features like a portrait,
which gave a strong impression of immediacy.
They were usually sewn onto the garments of
the dead with small gold discs. Since their use
spread as far as the Danube region and through
the Near East to the Orient, some relationship
between the various conceptions of the other
world in Eurasia has been presumed.

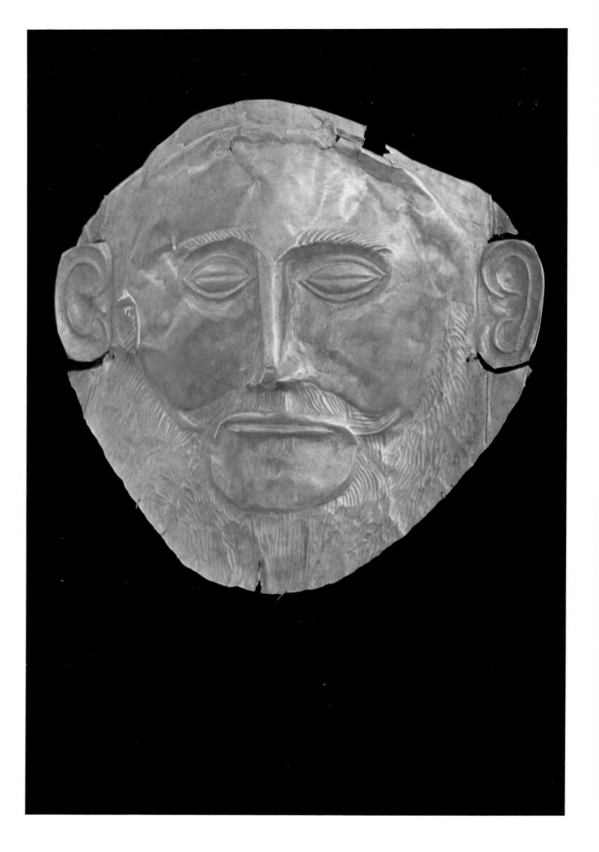

17a

André Derain

Mask with a wart

Alice Derain Collection, Paris

When Jean Laude described the situation of
the visual arts at the beginning of the 20th
century, he stated that at that time the work of
art itself became the reality, not an image or
expression of reality. 'Formal relationships must
now replace the logic of the image; these
logical relationships are therefore not so much
broken up or dissolved as re-arranged.' In
Laude's view Derain is first and foremost an
eclectic, whose hope of rejuvenating art 'from
the inside out and not in a formal sense'
belongs in a museum. The discovery of negro
art, in which Derain was involved, had a
different effect on him than on Picasso. It
confirmed his classicising tendencies. He was
looking for a way back into tradition, which
offered him security, and he did not want to
relinquish this. He was seeking a powerful,
solid form, and he found his justification in
African negro art. Thus primitive art had the
opposite effect on him than on Picasso, whom
it led to the dissection of shapes. Museums
provided Derain with very diverse subject
matter, such as bronzes from Benin (the Gulf of
Guinea), sculptures from the Mediterranean or
the golden masks from Mycenae. Derain
assimilated what he could use in his own work,
and his eclecticism became ever more blatant.
This mask is an example: it reproduces the
mask from Mycenae so exactly that the
comparison is almost embarrassing.

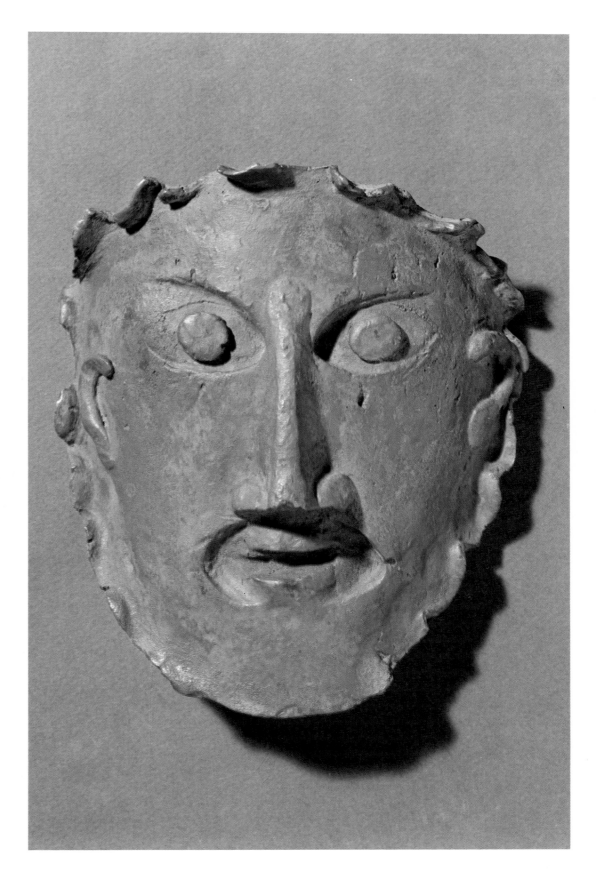

17b

Maya civilization, Mexico
Reclining Figure (Rain God)
National Museum of Anthropology, Mexico
This reclining figure, impressive in its noble
purity, represents the rain god Chac-Mool.
This, the 'Great Priest' is one of the
personalities of the god Quetzalcoatl. He holds
a bowl in his hands, in which sacrifices were
placed during religious ceremonies. His gaze
seems to go through man right into the world
to come.

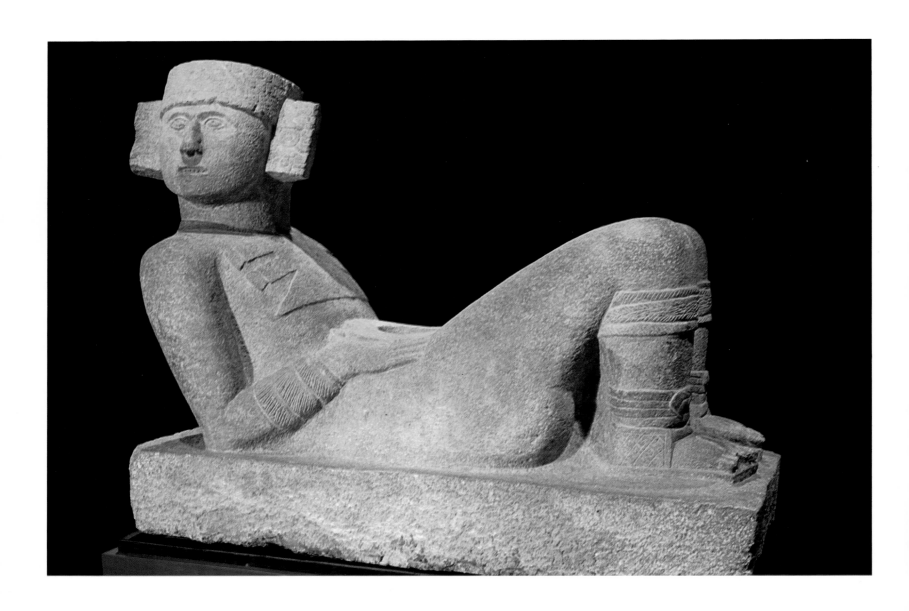

Henry Moore
Reclining Woman
National Gallery of Canada, Ottawa
In his representations of reclining women, Moore saw the possibility of projecting the individual attributes of womanhood onto the universal earth mother. In order to avoid geometric abstraction Moore constantly returned to the motif of a reclining woman, for woman belongs to an organic world. There is no place for geometry in this world. The stiffness of the *Reclining Woman* may derive from the Chac-Mool sculpture from Mexico. Moore consciously wanted to continue the traditions of sculpture in the ancient world, such as the Mexican and Egyptian. He never contested the fruitful influence of primitive art.

Pre-Columbian art also affected him, but the problem of imitation is not an essential one. On this point he wrote: 'Wherever an instinctive sensitivity to sculpture has arisen, the same shapes and the same relationships between shapes have always been used to express similar ideas and events, even in the most far-flung corners of the earth and the most remote ages in history; therefore the same conception of form lies behind a wood carving by a negro, or a Viking, or a stone figure from the Cyclades.'

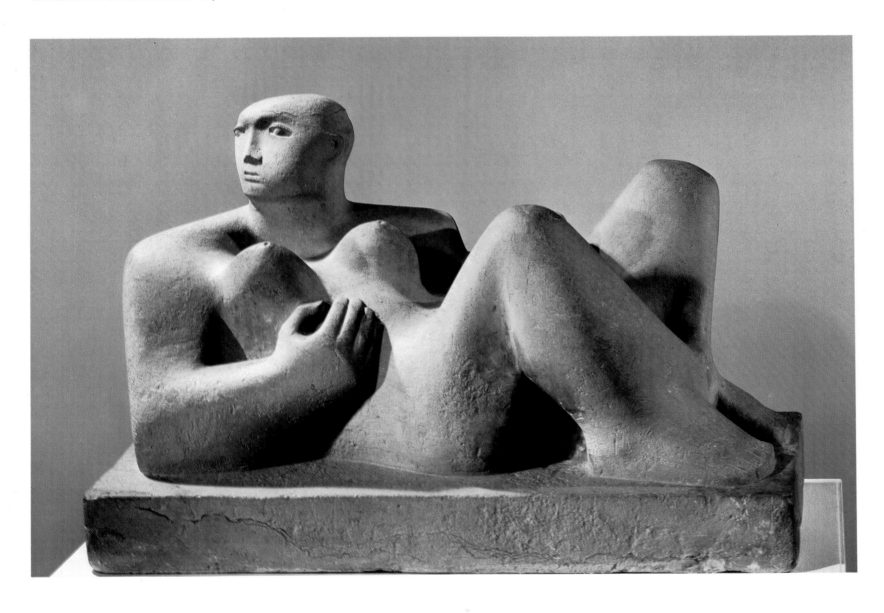

Dogon, Mali, West Africa
Crouching Woman
27 cm
Jacques Gagnière Collection, France
The wooden figure shown here was very frequently used in the rituals of the Dogon tribe. For this reason it is so thickly encrusted that the material is barely recognizable, but the emphatically geometric and rigidly cubist shapes are not affected in any way. This cubist modelling is very common in the sculptures of what was formerly the French Sudan. The head, which is almost completely abstract, with only a hint of the features, rests on a bulky neck and cylindrical body. The breasts are greatly emphasized, the arms are pressed close to the sides, and the hands, which are indicated only by a right-angled joint, rest on the thighs. The sitting or squatting posture shows that the figure very probably represents a person of high rank. In the Dogon tribe only the dead from the upper classes could be depicted sitting. Despite its small height, the figure gains a monumental quality from its logical and abstract structure.

19a

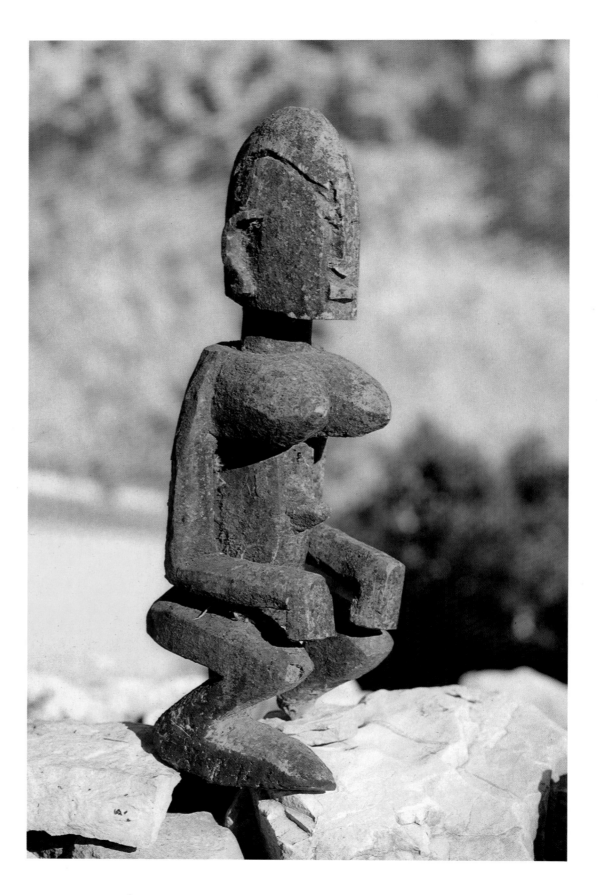

Fritz Wotruba
Seated figure
Stone, 125 cm
Private Collection, Switzerland
The sculptor Wotruba, born in Vienna in 1907,
was also influenced by primitive art. The
figures from Nokuoro in the South Seas
correspond to his conception of art, for here,
too, the faces have no individual features,
consisting purely of undifferentiated basic
shapes. The stiff cubism evident in the Dogon
sculpture opposite, also strongly influenced
him. His 'seated figure' follows the same cubist
principles. These influences fell on ready
ground in Wotruba. He had always wanted to
free himself from forms of sculpture based on
visual perception, such as could still be found
in Maillol. Wotruba was seeking the same
solutions in Austria as were Lipchitz and
Laurens in France; sculpture itself should take
precedence over the recognizable human
figure. Wotruba reduced the shape of the body
to cubist elements and based it in geometry.
Details were neglected in favour of
monumentality. His theme is always man,
whom he constructs architecturally. Working
with stone plays an important part in his
output, which represents an answer to the
spirit of our times.

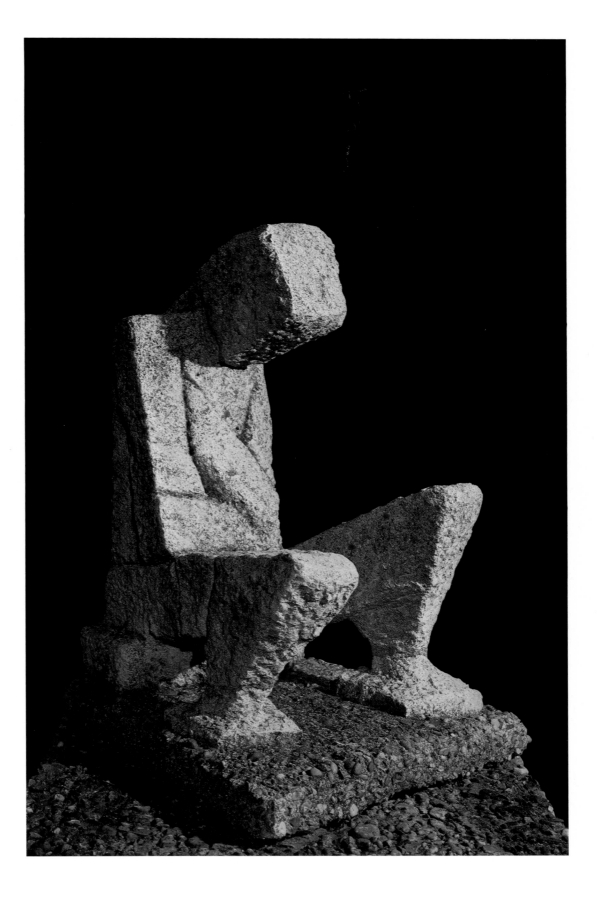

Songe, Congo (Zaire)
Kifwebe mask
Polychrome wood, 45 cm
Charles Wentinck Collection, France
The Kifwebe masks from the Congo are some
of the most astonishing and interesting forms
which African negro art has evoked. Only a few
other tribes, apart from the Songe, have
provided a mask which uses such a dynamic
language of shapes, such an inspired rendering
of, and arresting correspondence between,
form and decoration, form and colour. The
point of departure for the Kifwebe mask is the
human head. The eyes are turned outwards,
sticking out like cylinders. The mouth is also
over-emphasized. These distortions are nothing
to do with the expression of an aesthetic sense.
The eyes and mouth are stressed so much
because they are invested with a special
significance. The distortions increase the
intercessive powers of the mask with regard to
its tribal function: protection against illness, aid
in wars and the preservation of the tribal
leaders from misfortune. The mask is also used
in the initiation ceremonies. The ornamental
segmentation, of a high standard of
craftmanship, enhances its magic powers.

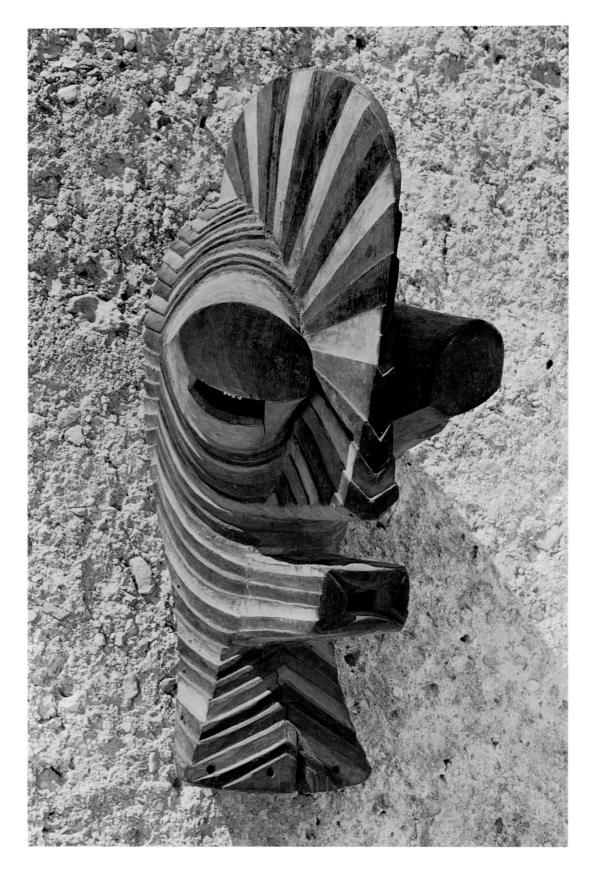

20a

Pablo Picasso
Portrait of a Woman, 1942
Oil painting, 10 × 81 cm
Thompson Collection, USA
The distortion in the face of the woman painted
by Picasso is as far removed from reality as the
Kifwebe mask opposite. Both seek to intensify
expression, but with the difference that the
mask is closely linked with the observance of a
worship essential to the tribe, while Picasso's
picture only has a decorative function: it adorns
the wall of a museum and is appreciated for its
aesthetic qualities. The Kifwebe mask, on the
other hand, always retained its magic powers
and scarcely altered its shape. It derives its
solemnity from a blood sacrifice; it is supposed
to ward off evil spirits during a ritual dance. It
has magic powers. Picasso's painting has a
significance only as an individual work of art.
Jean Laude remarks: 'The subject of this
painting is the painting itself' and goes on to
say, 'For Picasso, the problem is to take the
work to pieces in order to discover in all its
aspects the principle on which the
''functioning'' of the work depends. In so
doing Picasso remains strictly within the limits
of formal solutions.'

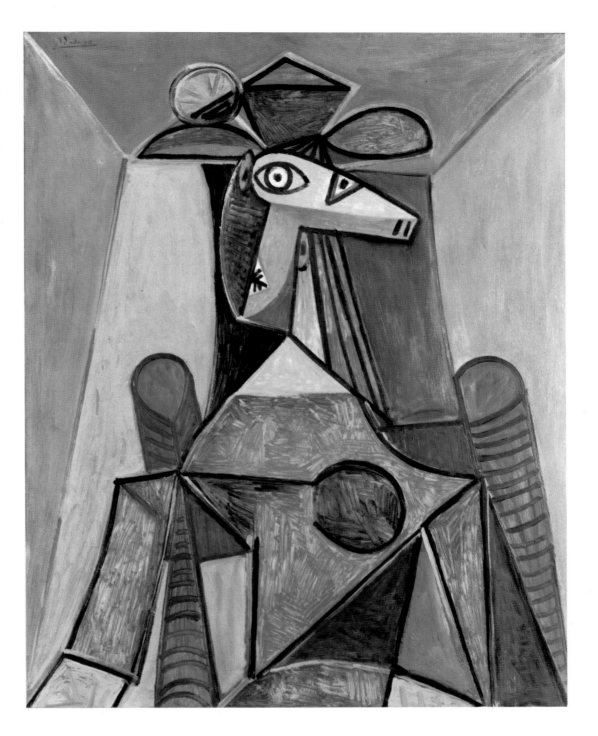

Umbria, Etruscan art
Bronze
Museo Etrusco, Volterra
The museum in Volterra owns many of these
elongated votive sculptures. The height varies
between 20 and 60 cm. The figures are highly
abstract and exaggerated in length. Only the
head, in accordance with Etruscan tradition, is
strikingly faithful to nature. No movement
disturbs the absolute tranquillity of the body's
posture. It is a sign of the peace which belongs
to eternity, not a recollection of the world and
temporal existence.

21a

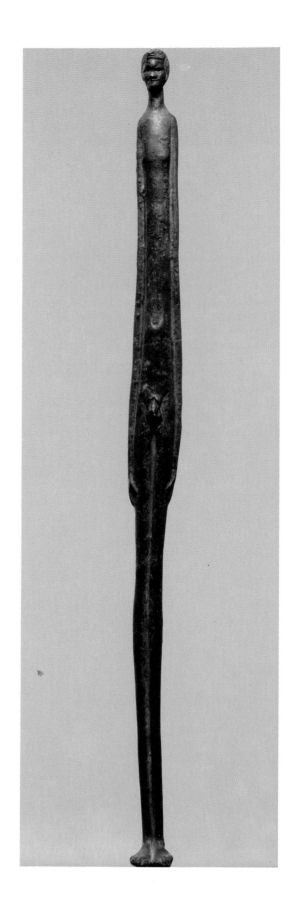

Alberto Giacometti
Venetian Woman, 1957
Bronze
Art Gallery, Zurich
Giacometti's links with primitive art were never really broken; but his attitude to it changed in the course of time. In about 1925 African art played a decisive role in his awareness of form. During the 1940's he evolved the filigree style which is now characteristic of him. There are possible parallels for his works in the Tellem figures of the Dogon tribe. These sculptures have 'evident stylistic connection with the modern works of the Dogon and are clearly of the same origin.' (William Fagg). But more significant is his relationship to the votive figures of the Etruscans. In Borowski's collection there is an elongated figure from 500 BC, in which the height of the human body would scarcely be increased. Giacometti also creates the illusion of an infinite distance between the observer and the sculpture. His stylized figure seems to belong to the realm of the dead rather than of the living. Nature and art are as far removed from each other as the physical and metaphysical worlds. The parallel with the bronze in Volterra can hardly be coincidence, the similarity is too great.

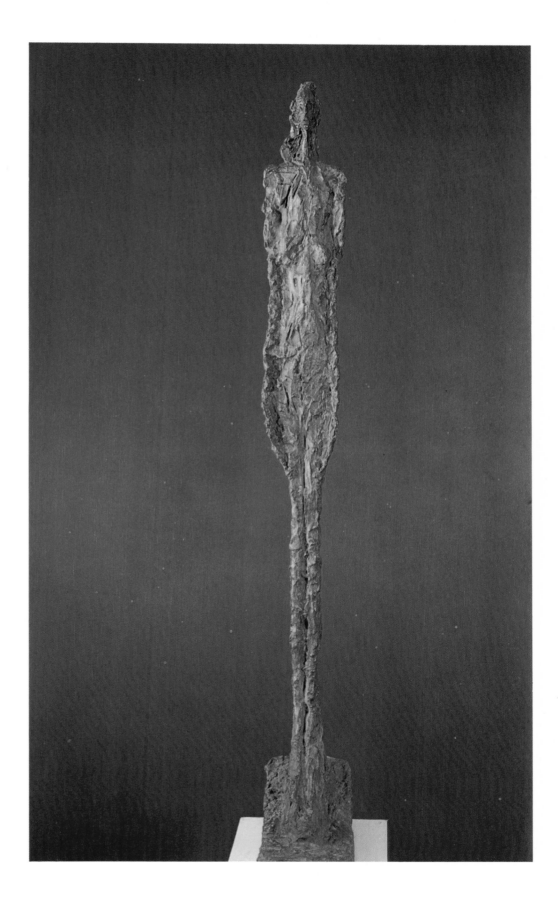

Quimbaya, Columbia
Human figure
500 to 1000 BC (?)
Clay, 30 × 23 cm
Rautenstrauch – Joest Museum, Cologne
These broad, flat figures with the triangular, often neckless heads, are typical of the Quimbaya style. The faces are flat too; only the nose protrudes sharply. The arms are thin and pressed close to the sides. There are still traces of paintwork. The structure of the human figure in this statue corresponds to visible reality, without, however, pretentions to similarity. The proportions are quite arbitrary: the legs are unusually short in relation to the body. The width of the head is excessive. It is the creation of a figure that is not subject to the laws of anatomy.

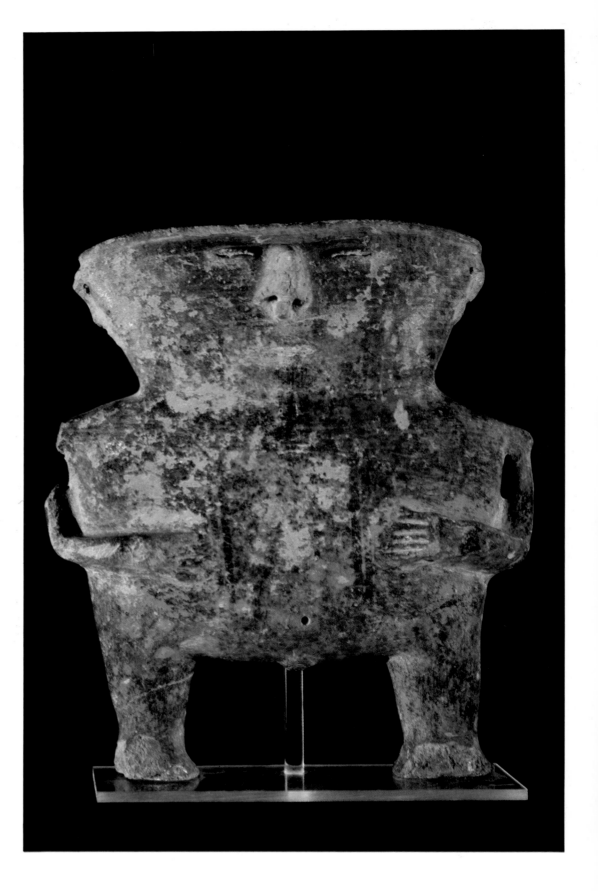

Jean Dubuffet
The Albino, 1958
92 × 73 cms
Hack Collection

Dubuffet painted many portraits, some of which are catalogued under the collective title 'Plus beaux qu'ils croient' (More beautiful than they think). This title demonstrates that he was not concerned with a similarity to the person portrayed. The catalogue explains: 'The portraits make every attempt to show the insignificance and contingent nature of physical characteristics.' When an artist regards the particularities of his sitter as irrelevant, he is close to the conceptions of primitive art. The comparison between Dubuffet's work and that of the Quimbaya demonstrates the link in ideas. In Dubuffet's work the width of the head is also disproportionate to the body. The position of the arms, the reduction of the body to a flat surface, the elimination of any facial expression and, especially, the depersonalization, the return to what the catalogue calls 'de figures très impersonnelles et élémentaires' (very impersonal and elementary figures): all result in a very remarkable harmony. It is clear that Dubuffet was familiar with pre-Columbian sculpture. His shapes are drawn from the 'Musée imaginaire' which the contemporary artist carries, consciously or unconsciously, in his mind.

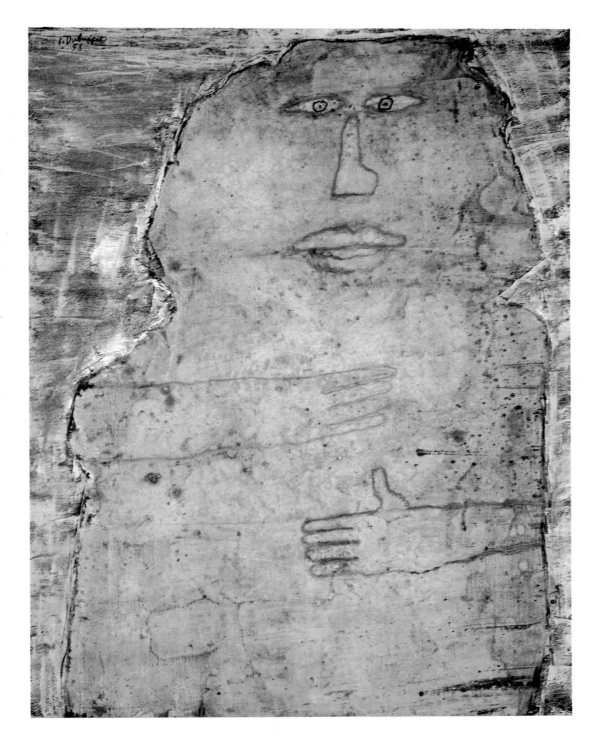

22b

Syria

Head of Astarte (Moon Goddess)
Terracotta, 2000 BC
Private Collection, Cologne
This figure, which comes from a culture
completely alien to us, was undoubtedly
connected with religious worship, and possibly
also with forms of magic to ward off
frightening spirits. What is most noticeable
about the figure of the goddess Astarte is that
it does not reproduce any visual reality but
rather imaginary concepts from the
metaphysical world. Its shape had an
exorcizing function. Human features are
avoided, the image of the god radiates a power
we cannot comprehend. Its magic could not be
expressed by a realistic representation. The
goddess' secret is kept.

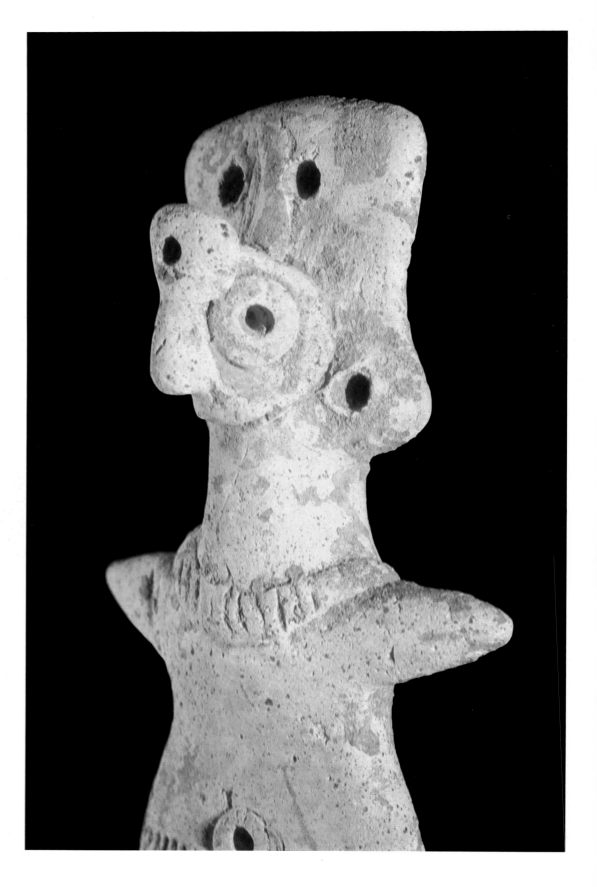

23a

Henry Moore

Head of the King, detail from the sculpture
Two Seated Figures
(King and Queen, 1952–53)
Bronze, 164 cm
Freilicht – Museum Middelheimpark, Antwerp
The shape of the king's head is particularly
noteworthy. For a time, Moore had reduced the
human head to the shape of a knob or a bulge
which only had formal meaning. Here,
however, the schematic form evokes something
alien and disturbing. The impassivity of his
earlier figures gives way to a powerful
expressive force. In this transformation Moore
achieves a remarkable correspondence with the
head of the Syrian goddess Astarte. In both
cases the concave surfaces suggest body; the
reduction of natural shapes leads to an
extremely abstract sculpture in both. The
'distortions' in Moore are apparently inspired
by exotic art and are more than mere
experiments with form. A more fundamental
process is going on in the deeper layers of
consciousness. Moore writes of his work: 'I am
not after beauty as understood by the Greeks or
by the artists of the Renaissance. There is a
functional distinction between beauty of
expression and power of expression. The
former seeks to please. The latter seeks to
reflect a spiritual vitality which is more moving
and of the deepest gravity for me.' The sitting
position of the couple shows links with the
enthroned royal couples of the Egyptians and
the wood carvings of the West African Dogon
tribe. The subject matter and solemn posture is
also in harmony with the examples quoted.
Erich Neumann sees a return to the 'collective
unconscious' in Moore's technique, and refers
us to C. G. Jung's theory of archetypes.

Boeotia, Greece
Idol in the form of a bell, 800 BC
Terracotta
Musée du Louvre, Paris

Picasso used the Boeotian bell idol as a model for many of his ceramics. In earlier centuries in the ancient world bells served to ward off evil and to influence the gods. They were first used to summon people to worship in the mystic rites of Bacchus. In the 5th century this custom spread to the Christian world. Picasso sought new forms of artistic expression in practically all previous civilizations, but his results are not always convincing. They worked initially through the fascination exerted by the bizarre, but after the shock effect all that usually remained was a recognition of the artist's virtuosity, which is not satisfying by itself. Whether Picasso's sculptures or terracottas take us back to the Stone or Iron Age, to the Sumerians, to Mesopotamia or to Boeotia, they are never born of instinct, as are the works of ancient civilizations. We may again pose the question asked by Pierre de Champris: 'In the complex case of Picasso, it is often very difficult to establish the motives behind his actions. Is he not subject to an inexhaustible gamut of feelings which are regulated by the malicious pleasure of making fun of himself and others? Where does the work of art end and the joke begin?' Picasso's gift for using alien art forms is undoubtedly proof of his quick comprehension. It is evident in his use of the Boeotian bell idol. But who should take precedence: the artist of 800 BC or that of the 20th century AD?

24a

Pablo Picasso
Ceramic
Musée Grimaldi, Antibes
The depiction of the human figure in manifold styles pervades the whole development of Picasso. In *Les Demoiselles d'Avignon* he tried to fuse the classical structure of Cézanne with the anti-classical facial features of Negro masks. But he only partially succeeded in harmonizing these contrasting conceptions. The daemonic element often upsets the symmetry of the composition. The shapes are filled with primitive magic. A few years later 'Europe' is again uppermost in Picasso's mind. This is his attempt to grasp the hidden reality with the help of classical art, but he creates a classicism which lacks its faith. Fear and unease underline it, only to destroy his classical Arcadia violently again in 1925. With the primitive pre-classical image of the minotaur Picasso acknowledges the claims of the horrific. He continually draws on the Mediterranean world. The delightful bell idol from Boeotia was definitely the inspiration for the charming ceramic of a woman depicted here. It is a particularly interesting example of Picasso's ability to create an abstraction, to fuse heterogeneous elements together and perhaps also to smile a little with the observer.

24b

Early Greek

Boat and Crew, 700–600 BC

Terracotta

Museum in Nicosia, Cyprus

It is very likely that the boat shown here was a sacrificial offering. With such gifts people sought the assistance of the gods in a safe journey, and offered thanks for the return. There are still parallels for this today. In many Christian countries models of ships are brought as votive offerings to entreat the protection of the Virgin against the many dangers of a sea journey. Well known examples of this are the many models of ships in the church of Les-Saintes-Maries in Provence. Small boats were also found in tombs in ancient Greece. Such works of art can always be traced back to a religious function. There are some in negro tribes on the West African coast, such as the Duala people in the Cameroons, who made canoes in high class filigree for use in religious ceremonies.

Alex Kosta
The Journey, 61 × 37 cm
Claude Bernard Collection, Paris
It is unusual for a sculptor of the 20th century
to choose a boat and crew as a subject. Most
modern artists generally avoid anecdote. Kosta
obviously conforms to a tradition which had
remained alive in his consciousness. It is not
clear whether the artist was affected by the
religious background.

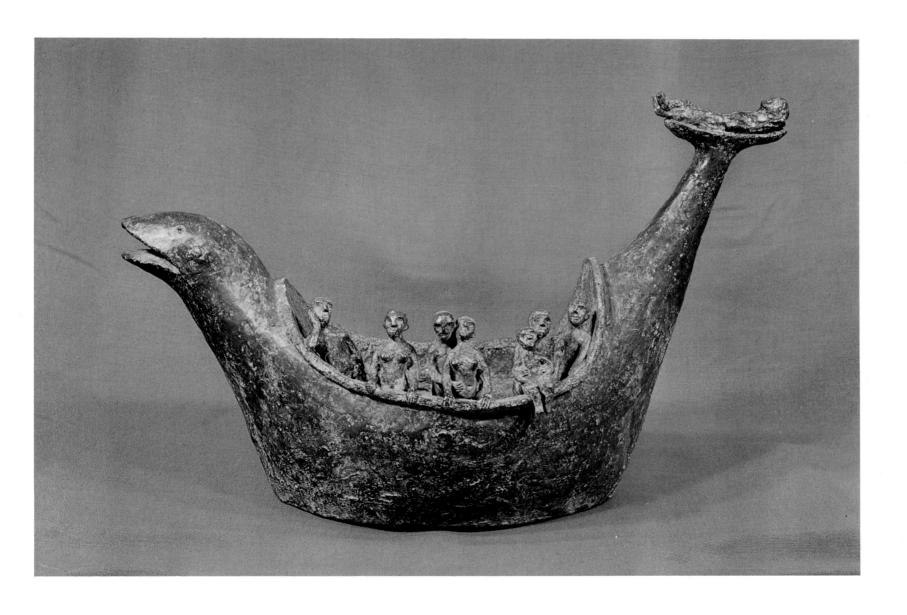

Kissi, North East Sierra Leone and
South West Guinea
Standing figure
Soapstone, 19 cm
Private Collection, France

There exist in Kissiland stone figures from
earlier centuries as well as wooden sculptures
from the more recent past. Besides the
sculptures in soapstone of the Kissi people,
called Pomtan, there is other soapstone work,
such as the Nomoli of the Sherbro-Bulum tribe
and the sculptures of the Temne, which are
notable for their free flowing and elegant lines.
The Pomtan have strong negroid faces with
large bulging eyes, thick lips and broad noses
with wide nostrils. The figures are either sitting
or kneeling. The hands lie close to the short,
squat body. These Kissi figures frequently have
an archetypal smile. They belong to ancestor
worship, are used as oracles and are still
venerated today on family altars. The human
figure is represented as a compact mass; no
detail is detached from the basic shape.
European sculptors of the 20th century, such
as Ipoustéguy, were also led back to the
fundamental concepts of sculpture by their
encounters with Kissi art. No gesture, no
anatomical detail nor proportion owes its
existence to nature; this art knows only
massive, simple, and self-contained forms.

26a

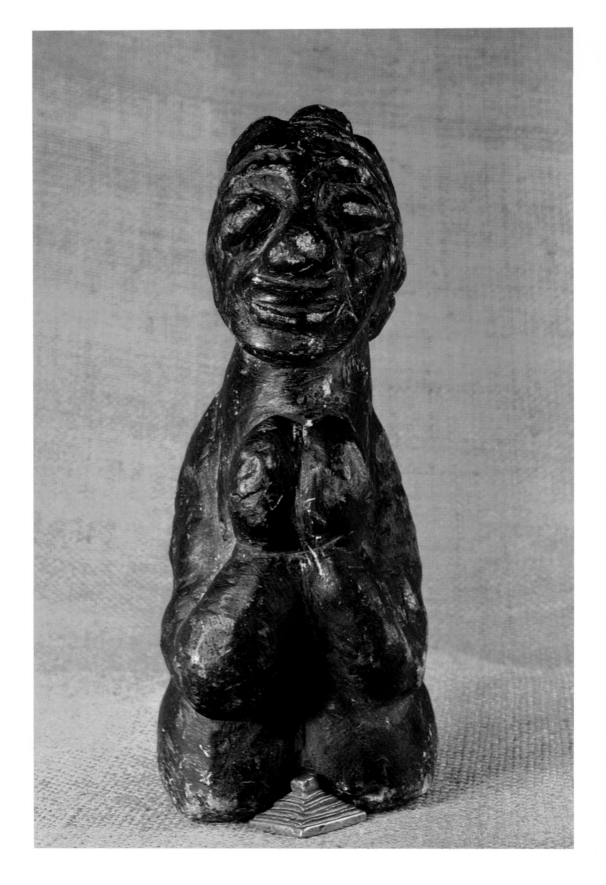

Jean Ipoustéguy
Standing figure
Stone, 57 cm
Property of the artist
This French sculptor, born in 1920 in Dau-sur-Meuse, began as a painter and then, under the influence of Henry-Georges Adam, turned to sculpture. He broke away from the academic style of his youth and pursued abstract art. Nearly all the work in this period, however, still contains conscious references to the world of objects. He later returned completely to this sphere, and evolved a style which is characterized by a morbid elegance and an absurdity sometimes related to Surrealism. The figure shown here demonstrates the artist's interest in compact shapes. No detail is freed from the whole. The structure is simple. By means of a compact mass, Ipoustéguy realizes what other artists sought to achieve in Cubist structures – that is, a rhythmic composition built up from geometric order. In this he is reminiscent of Stone Age sculptors and the stone figures of the Kissi tribe. They have in common an almost ungainly segmentation and reduction to rudimentary forms. In its formal rigour, Ipoustéguy's figure seems carefully weighed and considered. He achieves the expressive power of its monumentality, not by copying nature, but by drawing inspiration from natural forms. This is his link with primitive art.

26b

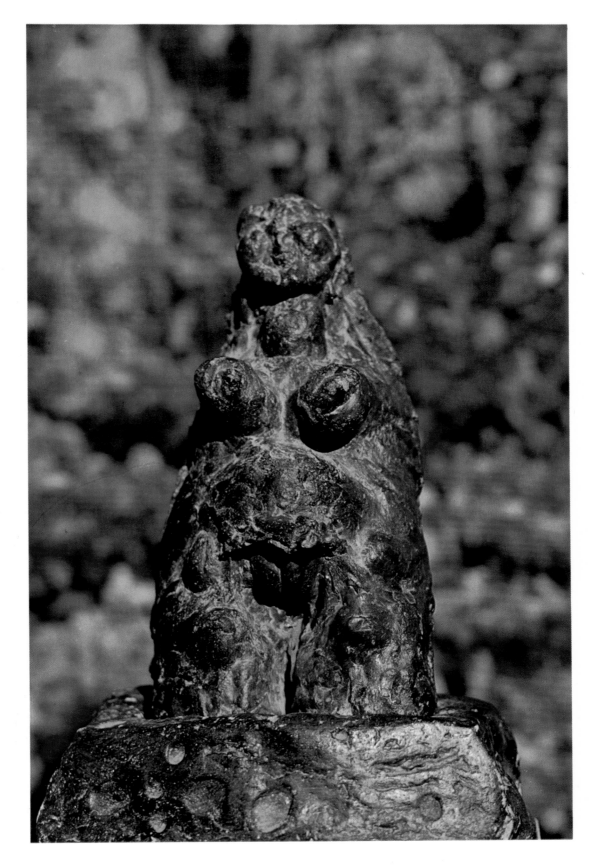

Paleolithic Age

Statuette of a woman

Lake Trasimeno

Arturo Palma Collection, Florence

In the cave paintings of the Paleolithic the representation of the man in his vital activity as hunter plays an important part. In the small sculptures of this age, on the other hand, it is the representation of the woman, who must assure the survival of the community in her own way, which predominates. Her image is used to pray for fertility. Such fertility idols are common in the paleolithic age. The female figure is drastically stylized and reduced. The goddess reproduced here makes it clear from her bloated form that she is a symbol of motherhood: the female characteristics most important for her role – breasts and hips – are especially emphasised, as are the genitals in other similar sculptures. In proportion to the rest of the body, the arms and legs are neglected or absent altogether. The face is usually represented only as a pure shape without any details. Here the head is not even present. This simplification has nothing to do with aesthetics, unlike the *Black Venus*, which strives for formal perfection.

27a

Brassaï

Black Venus

20.5 cm

Artist's Collection

Brassaï's works are characterized by the search for the primeval archetype. He is slightly reminiscent of Arp and Brancusi, although Brassaï preserves his personal style. His material is marble or granite. Like Arp he fashions the surface painstakingly and at length. There is an undeniable relationship with the sculpture of the Cyclades islands. The *Black Venus* recalls their polished finish and reduced shapes. The Cyclades sculptures were fertility symbols with pronounced female forms; other details of the anatomy, such as head, arms and legs were abstracted into a unified and compact whole.

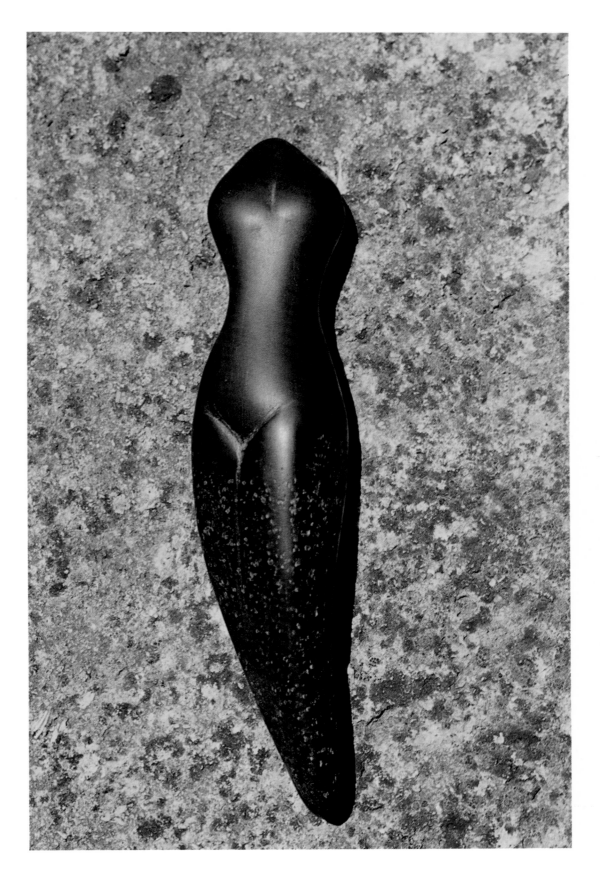

27b

Dogon, West Africa
Stake
Wood, 185 cm
Charles Wentinck Collection, France
This pole, which here stands alone in the
landscape, should really belong in a native hut.
In the fork at the top, a beam carrying the roof,
made of foliage, was placed. The men of the
village met in this hut, which was called the
Toguna. It was very often built on a mound. In
most cases these supports were decorated on
the outside, sometimes simply with a human
figure, sometimes with a combination of
ornaments. The upright shown here reproduces
a very simplified human figure on the top half,
and beneath it, two large female breasts. These
are a symbol of fertility and venerated as such.
The woman as mother guarantees the survival
of the tribe. Nothing could be further from the
African artist's mind than the creation of a
cheap erotic effect.

28a

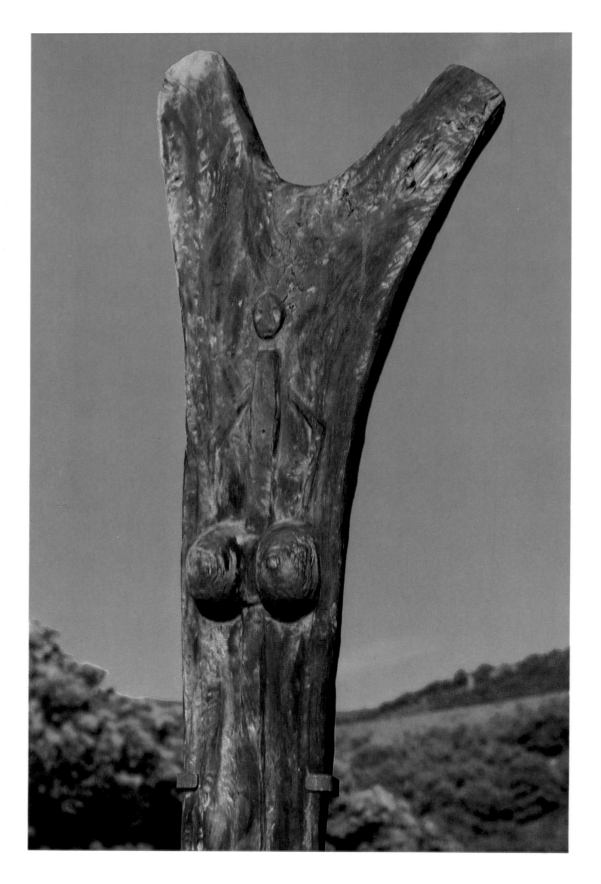

Kenneth Armitage
Sculpture of two breasts
The Legend of Skadar, Version 5, 1965
Bronze
H. E. Smeets Collection, Holland
The British sculptor Armitage, who was born in 1916, has made several versions of a sculpture of two breasts. He has not made clear to the observer what his artistic intentions are. There are parallels in ancient Greek tombs; the tombstone is sometimes decorated with a phallus, and crowned with a carved portrait. Armitage has reduced the female body to a pair of breasts. Today, such a sculpture obviously is not to be considered as an object of worship. What remains is a curious work with erotic associations open to personal interpretation.

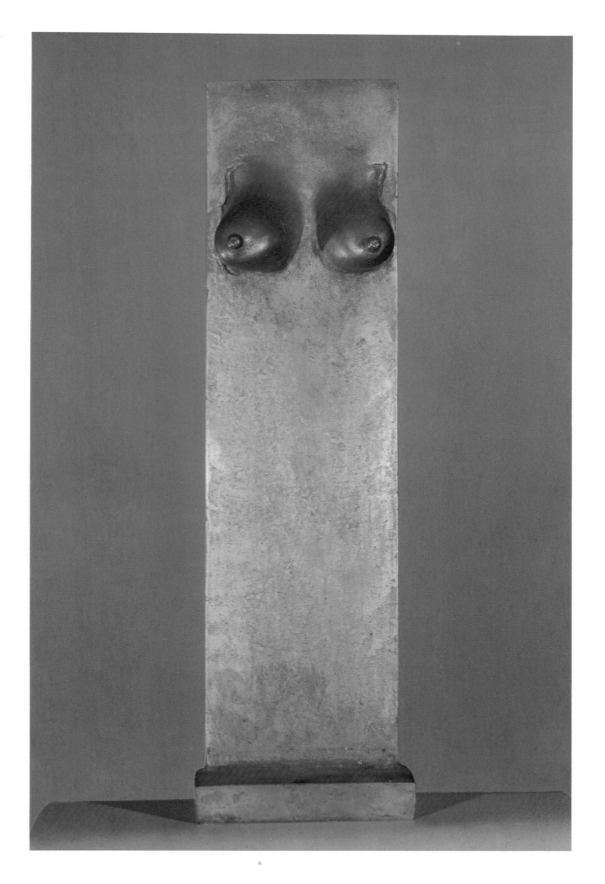

28b

Truk Islands, Micronesia
Ornament for a ship's prow
32 cm
Rautenstrauch-Joest Museum, Cologne
The inhabitants of the Caroline islands were
superlative craftsmen. They achieved
exceptional harmony and beauty of form in the
artistic embellishments made to their Malayan
sailing boats. These large boats, which
permitted communication between individual
islands, are marvels of technical ability and rich
imaginativeness. They were not carved from a
single trunk, but assembled from several pieces.

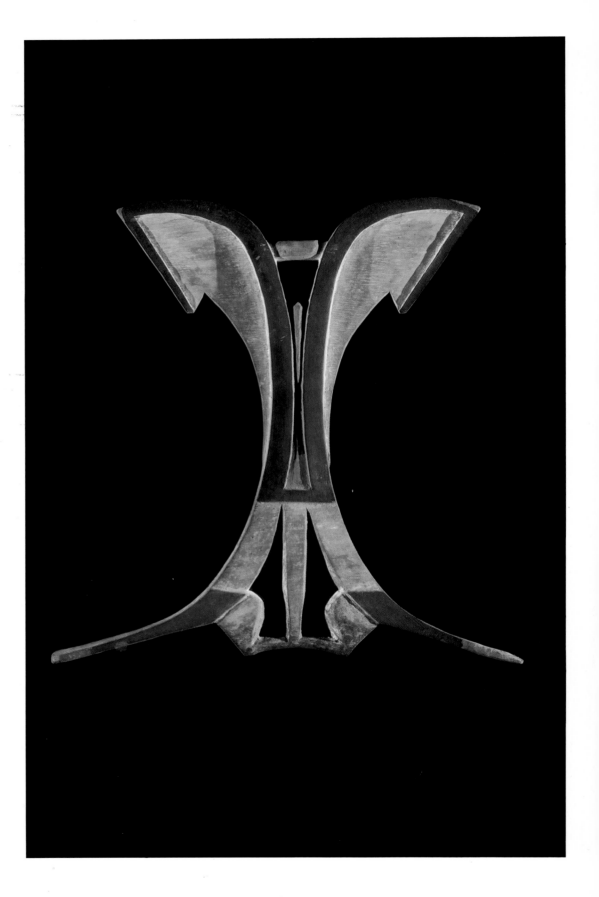

29a

Hans Uhlmann
Bird, 1954
Iron, 48 cm
Private Collection, Germany
Hans Uhlmann, who was born in Berlin in
1900, first studied engineering. He has been a
sculptor since 1925 and was classified as a
'degenerate artist' by the Nazis. He was one of
the first Germans to be interested in wire
sculptures, for which he used iron and other
metals. In his composition he works according
to principles taken from engineering.
Sometimes he takes visual reality as his starting
point, such as in his sculptures of birds; even
here he does not copy slavishly, but obeys his
inner vitality.

Peru, Pre-Columbian Art
Human figure (cloth)
13th century?
40 cm
J. J. Gardenier Collection, France
These Peruvian dolls were burial offerings. The base was fashioned from bark and covered with different fabrics. The face was painted on to the material with natural colours. Sometimes terracotta was used for certain parts. The arms are movable, and the fingers individually wound round with thread. Although the doll shown here is about seven hundred years old, the favourable climate has preserved it unusually well. The 19th-century dolls of the Hopi Indians in Arizona preserve the tradition of these Pre-Columbian dolls almost unchanged.

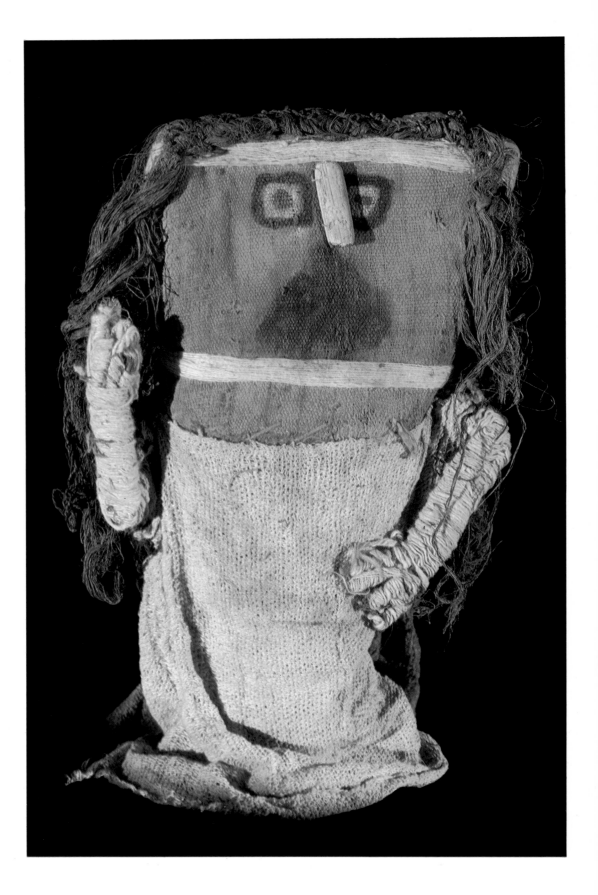

30a

Enrico Baj
Collage, 1969
Private Collection, Paris
The Italian painter Baj, who was born in Milan in 1924, first belonged to a neo-Dadaist group. He remained faithful to this tendency, but frequently added to it an element of bitter humour. His collages, for which he used the most diverse materials, have both child-like traits and distressing features. He was influenced by the 'Musée Imaginaire' in his search for form. The aesthetic ideas of André Malraux have become so much a part of the 20th century that probably no artist succeeds in avoiding a confrontation with the 'psychology of art'. When Baj encountered the Peruvian doll from the 13th century, he wanted to capture some of its subtle magic for our times. Admittedly he only drew on it for formal inspiration. He transformed the religious burial offering of the Peruvians into carefree cheerfulness.

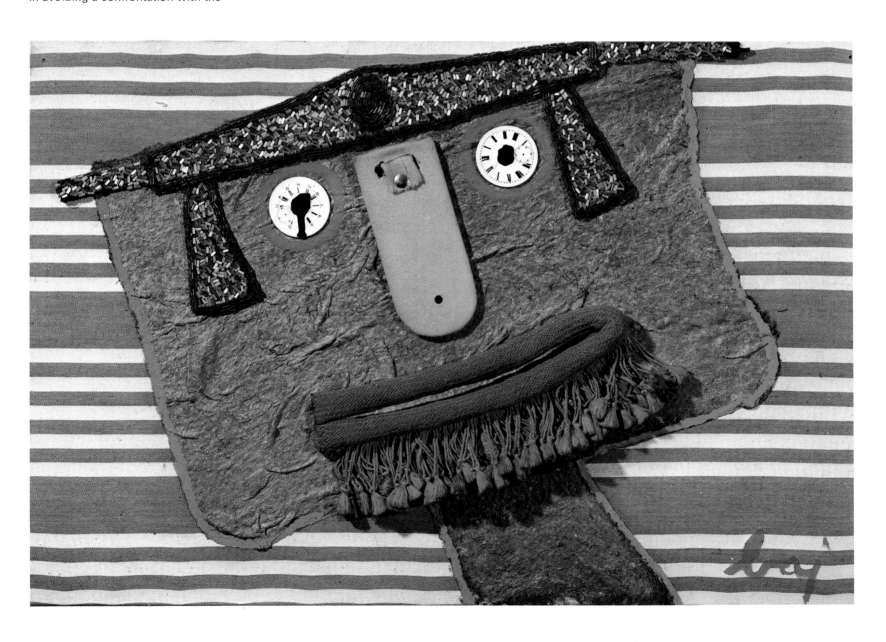

Marsoulas, Haute-Garonne, France
Human face on rock
Early Stone Age, 20 cm
Reliefs as well as cave paintings have been
found in the 'Magdalene' layers of the early
Stone Age. These petroglyphs (wall paintings)
in Western Europe usually depict symbolic
signs and animals, but occasionally also human
figures. They were chiselled out of the stone
with flints. The cave paintings of this period
represented the magic spheres of the hunt and
fertility, and were probably connected with
religious worship and myth. Recent discoveries
in such caves have significantly increased our
knowledge of these pictures. This applies to
paintings and engravings. On exposed sites
only the reliefs have been preserved. A
powerful expressiveness is give to the relief
shown here by the sharp outline of the nose,
the close-set eyes and the narrow mouth.

Jean Dubuffet
Michel Tapié Soleil, August 1946
Painting, 109 × 87 cm
Private Collection, New York
The portrait that Dubuffet did of his
contemporaries (Pierre Benoit, Marcel
Jouhandeau, Antonin Artaud and many others)
appear to be akin to children's drawings. They
are not concerned with anatomic accuracy. The
vague sketchiness of the shape of the body and
features is also reminiscent of drawings by the
mentally ill. Dubuffet himself calls this type of
drawing 'Art brut' (crude, unrefined art). In his
view it is the opposite of what art should be.
For this reason he also talks of 'anti-art'. His
portrait demonstrates a 'primitiveness' which is
not based on preconsciousness or
subconsciousness but on a carefully prepared
plan born of shrewd calculation. He is also
aware, like his intellectual contemporaries, of
the rich profusion of forms in the 'Musée
Imaginaire'. The portrait shown here is
obviously influenced by the Akua'ba (fertility
idols and dolls which are almost abstract) of
the West African Ashanti tribe. Dubuffet's
portrait has a disproportionately large, disc-
shaped head, small arms which stick out at
right angles and a small, cylindrical body. His
technique is the same as the pre-historic
paintings from the Haute-Garonne in France: a
crude weathered material is used as the base
for the painting, which has admittedly been
constructed artificially and with great
sophistication.

Tibet
Lama Mandala, 18th century
Tempera, 62.5 × 37 cm
State Museum of Folk art, Munich
Mahayana-Buddhism, which has been
producing new art forms in Nepal, Tibet and
Central Asia since the 13th century, makes use
of the mandala, a kind of diagram that
represents spiritual elements as aids to
meditation: it fuses a large number of symbols
and figures in order to illustrate the Buddhist
conception of the world. This esoteric
Buddhism symbolizes its world as a circle and
a square. The five Dhyani Buddhas and the
tides of the world in their respective colours are
portrayed here in this cabbalistic arrangement.

32a

Allen Atwell
Triptych, 1971 (detail)
Acrylic with gold leaf on canvas
Private Collection, New York

Atwell, who belongs to the New York school, has long been interested in motifs drawn from Tibetan art. In this triptych – only the central panel is shown here – he has depicted the mandala, a Tibetan meditation diagram which symbolizes the unity of the world by means of circles and rectangles. Atwell often varies this theme. While Tibetan art includes gods and saints in the diagram, Atwell replaces these recognizable figures with abstract ones, seeking to convey the life current of cosmic energy. He expects the spectator to be ready to absorb this concentrated energy through contemplation. The question whether the introduction of symbols belonging to a completely different world serves any purpose remains open.

El Castillo (Santander)
Cave drawing, Paleolithic
Rectangular feminine symbols and
complementary male spots, or dots, are
arranged in rows.
These drawings are between 30 and 60 cm
high. The interpretations of the cave drawings
at Santander vary considerably. Similar
symbols have been found in the grottoes of La
Pasiega, also in Spain. It was the Abbé Breuil
who first attempted to decipher them. Various
scholars searched for related symbols in
primitive tribes today. They interpreted the
rectangular signs as a roof, a house or a hut,
with the lines as beams. Similar symbols in the
caves at Lascaux were considered to be animal
traps. Leroi-Gourhan put an end to these
imprecise explanations. He saw in these
drawings not images of real objects but
symbols inspired by the phallus and the vagina.
He produced proofs of this. The drawings also
allude to metaphysical relationships. Gourhan
believes that they are proof of a paleolithic
religious system which was not at all as simple
as has been presumed until now.

Pierre Tal Coat

Drawing, 1965 (Painting I and II)
Galerie Maeght, Paris

It is already evident from the titles of his pictures (*Déesse-Mère*; *Nuit sur le Silex*) that Tal Coat is closely connected with primitive art. He has called the work shown here *Points rouges sur le rocher* (Red spots on the rock). In his book Henri Maldinay points out the relationship between the *Points Rouges* and prehistoric cave paintings: 'The masters who are closest to him are the great artists of the Paleolithic, those of Lascaux.' The link between the two is very clear, although there is no such relation to religious worship in Tal Coat, as Leroi-Gourhan has established in the cave paintings. What was an intelligible language for the cave dwellers of prehistory is a purely aesthetic phenomenon for the 20th-century artist.

33b

Elema, Gulf of Papua, New Guinea
Dance Mask
Bark, 54 cm
Rautenstrauch-Joest Museum, Cologne
This mask symbolizes a forest spirit. What is so
striking about the face is the two dark-rimmed
eyes and the strange triangular mouth. The
broad base of the nose, which is sharply
outlined, extends upwards beyond the eyes.
The face is given unity by a ruff which varies in
width. Steinberg says that in the conception of
his mask shown opposite he was influenced by
the primitive art of New Guinea, although not
of Papua, but of the Sepik tribes. He adapts the
same principle freely.

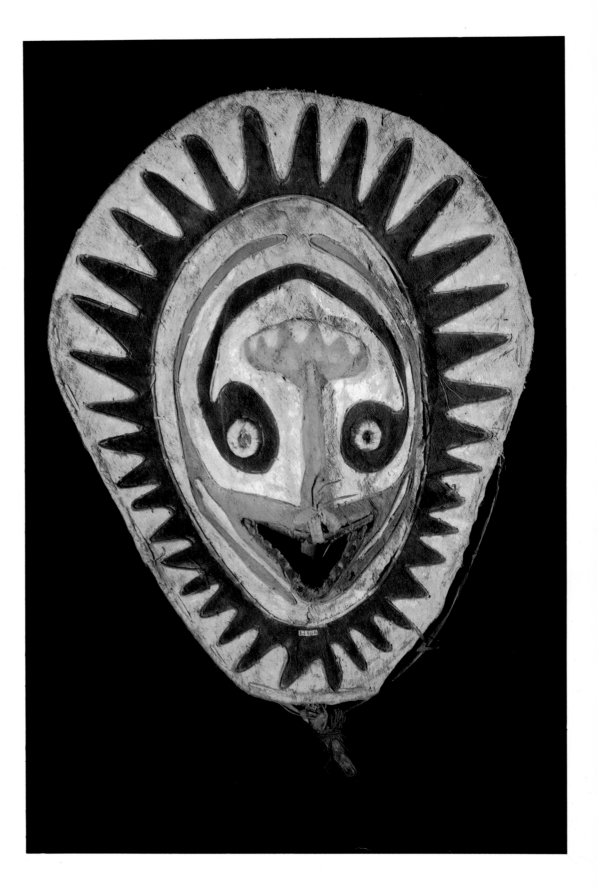

34a

Saul Steinberg
Philanthropic mask, 1964–5
Collage
Galerie Maeght, Paris
The American painter Saul Steinberg, who was born in Rumania in 1914, was originally an architect. Sometimes the childlike naiveté of his paintings is reminiscent of Paul Klee, though he denies any direct influence. Steinberg himself explains that he has a strong attachment to the 'primitives without a name'.

For him masks have become the 'basis for his confrontation with society'. (Schneckenberger) In one *Business mask* he uses features of the Kalunga mask of the Bembe tribe. The *Philanthropic mask* shown here transforms similar facial subject matter from the Sepik region (New Guinea) into the 'flattering war-paint of a lady whose favours are her livelihood'.

Bakongo, Lower Congo
Fetish of nails
Wood and other materials
Rautenstrauch-Joest Museum, Cologne
There is no object on this fetish that has been created or attached to it for purely aesthetic reasons. Antilope horns, pieces of bark or material, strips of leather, seeds or nut kernels, feathers or pearls – all serve only to increase the powers of the fetish to ward off malediction and provide protection. Magic substances are concealed in the helmet-like decoration. The pieces of mirror in the eyes are supposed to emphasize the figure's powers of entreaty. The stance shows that it is ready for attack; the raised arm and jutting chin create a forbidding impression. The nails and pieces of iron which have been driven into it are not decorative. They are, rather, proof that the fetish is intended to give aid in all of life's difficulties and increase the tribe's ability to withstand attack.

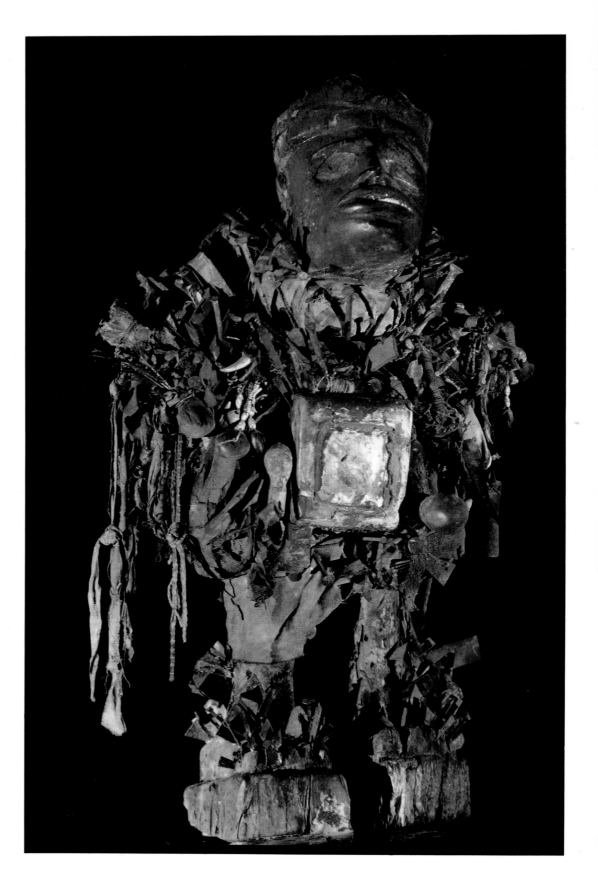

Paul van Hoeydonck
Little cosmonaut
38 cm
Artist's Collection
This sculpture, as far as such a name still has meaning, represents a cosmonaut. It has been constructed from machine parts and other waste from the production process. Its similarity to the nail fetish from Bakongo is evident. The Belgian artist has undoubtedly had many opportunities to familiarize himself with fetish art from the Congo in his own land. The helmet-like structure of the head, and a surface built up from all kinds of materials, such as bits of iron and other waste products of industry, contribute to this similarity. Van Hoeydonck's statuette has no purpose in ritual or any religious connection. Nevertheless, it does have symbolic significance. It shows a man of the mid-20th century, who has degenerated into a being whose natural functions – such as breathing, sight, hearing, speech and gesture – have been replaced by mechanical ones. When man became a cosmonaut, he so removed himself from nature that he had to replace his natural functions with technical ones in order to survive. The artist's encounter with the nail fetish has borne fruit. He drew on it for inspiration in the external structure of his figure while changing the symbolic content.

35b

Mende, Sierra Leone, West Africa
Bundu mask
Wood, 40 cm
Charles Wentinck Collection, France
The Mende are the most important tribe in
Sierra Leone. Their most valuable works of art
are the Bundu masks of the Sande, a group of
women who take care of the girls' upbringing.
They learn everything they will need to know in
their later life, as wives and mothers. Song and
dance are also part of their education. In the
concluding ceremony the Bundu-devil appears,
wearing an inverted mask and a cloak woven
from leaves. He is the guardian spirit of their
society. Typical of these Bundu masks is the
high coiffure which crowns the head, and a
face which is usually small, with delicate
features. According to Boris de Rachewiltz this
hair arrangement is a symbol of the female
genitalia. They are venerated and portrayed in
several African tribes, for they are fertility
symbols. These masks are only worn by the
Sande.

36a

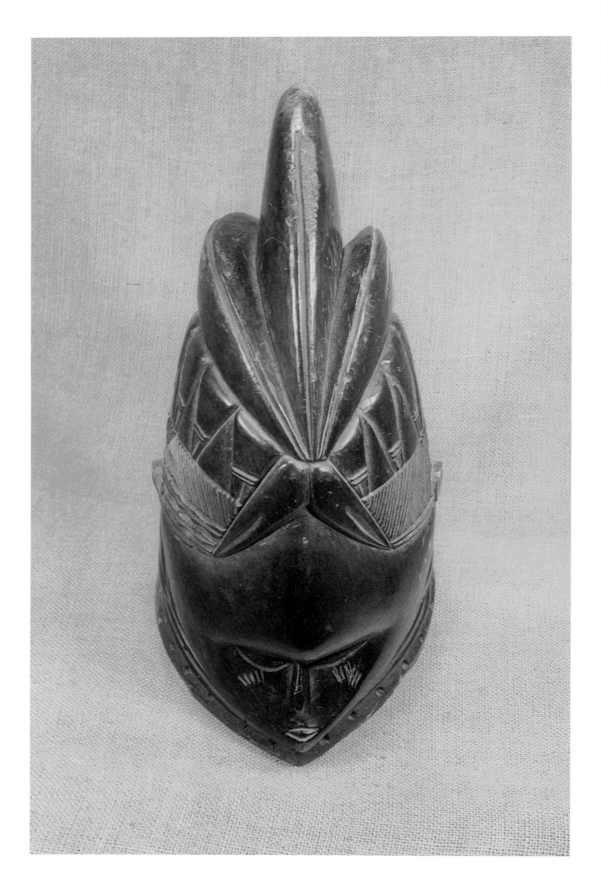

Caroline Lee
La Femme, comme il faut
Brass, 65 cm
Private Collection, France
This metal figure, representing woman 'as she
should be', no doubt, is meant to be ironic. It is
male fantasy rather than female reality. Caroline
Lee's vision is linked to prehistoric and
primitive art. Woman is reduced to her function
as the ancestral mother, or earth goddess. The
relationship with the coiffure of the Bundu
mask can surely not be coincidental. In both,
the image of woman is pared down to a vagina
with a clitoris and other female characteristics.

Goejerat, India
Tantra painting, 15th century
Gouache on canvas, 55 × 53 cm
Tantra is a religious Buddhist movement which
emerged in India about AD 500. It teaches that
all things in the universe stand in a mystic
relationship to each other. Its rituals contain
advice for the procedure of initiation to
meditation and mystic chant. The parallels
between Tantra and the doctrines of Mahayana
Buddhism are evident in the painting shown
here. Like the mandala of the Mahayana
doctrine this is a diagram of meditation and
thought. Octavio Paz called Tantra art 'a rigidly
structured system, to which nothing can be
added'. Therefore if a modern artist adapts
elements from the Tantra system, this can only
be based on a fundamental misconception. Paz
continues; 'Modern art presents itself as a
language which cannot be reproduced in other
languages'. The language of Tantra
encompasses the whole of the universe. A
modern artist is incapable of translating it
because of its close religious links. For this
reason Paz believes that the works of
contemporary artists who draw on Tantra art
have no relevance. The Tantra painting shown
here, on the other hand, draws the spectator
into its magic system of circles, symbols and
figures, even if its symbolism remains a secret
to him.

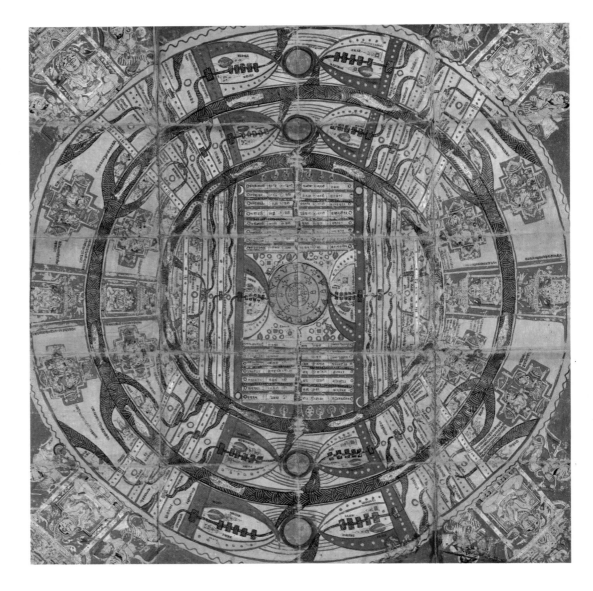

Hundertwasser (Fritz Stowasser)
Sun and spiraloid over the Red Sea, 1960
Oil, 114 × 145 cm
Siegfried Poppe Collection, Hamburg
The painter Hundertwasser, who was born in
Vienna in 1928, was first stimulated by
Austrian Baroque and Art Nouveau; later by
Persian and Indian miniatures. These diverse
influences are reflected in his works. In 1952
he gave himself over to a decorative, abstract
style. His major motif is the spiral, which he has
painted under numerous guises – in houses,
landscapes, human figures and fantastic
abstracts. His predilection for oriental colouring
is emphasized to such an extent that the
subjectivity of his expression can sometimes
become a delirium of colour. Hundertwasser's
use of the spiral has nothing in common with
the symbolism of spirals in the Far East, where
it is grounded in religious worship. In the
brilliantly-coloured painting shown here the
spiral motif has become a labyrinth with
evident echoes of Art Nouveau. Nevertheless,
association with the structure of the Tantra
painting opposite can also be detected, though
Hundertwasser's work bears no inner relation
to the pure tranquillity of Buddhism.

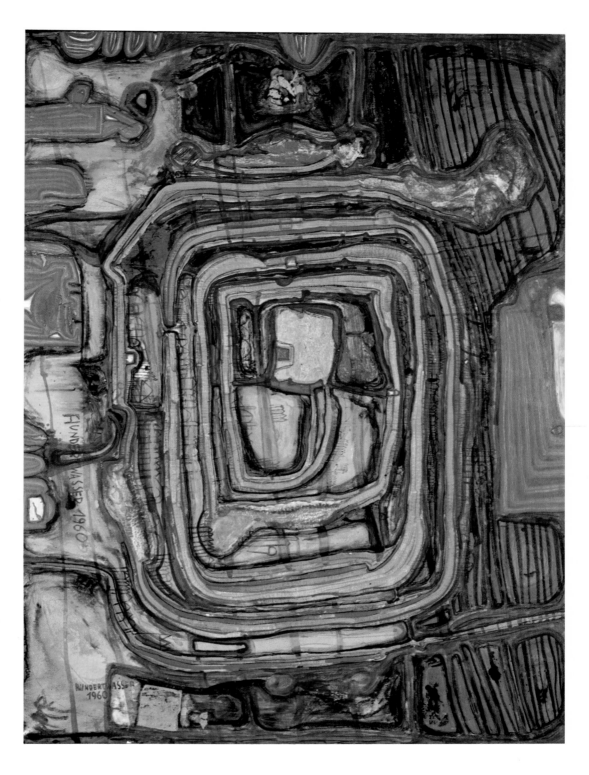

Easter Island, Polynesia
Stone sculptures
About 16 metres high
The massive sculptures of Easter Island are images of the gods, which were worshipped as holy shrines, and perhaps partly as ancestral symbols. Characteristic of these grandiose forms is the jutting brow which casts the eyes into shadow. The powerful nose also protrudes above the thin-lipped mouth. These figures are carved from a single block, quarried from the volcanic limestone of the Rano-Raraku. These huge monoliths symbolized the magnitude and power of the next world. They were carried to the sea's edge and erected there – a remarkable technical achievement for the ages before Easter Island was discovered on Easter Day, 1722. The monumental forms and boldness of these sculptures is overwhelming. There are three hundred of these giant figures on the island.

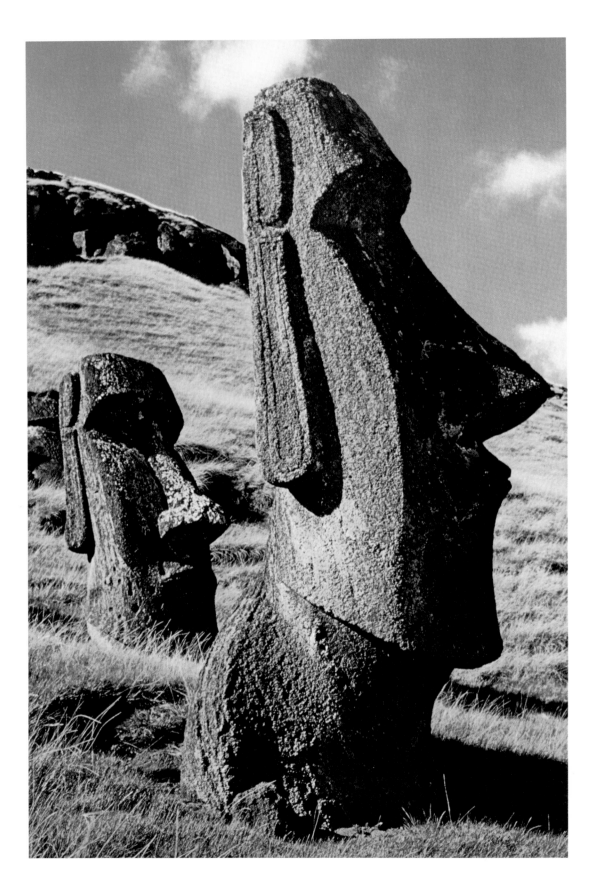

André Beaudin
Portrait of the poet Paul Eluard, 1948
Bronze, *c*. 43 cm
Louise Leiris Gallery, Paris

Whoever sees this monumental portrait of the
poet Eluard by André Beaudin, is reminded of
the huge stone figures on Easter Island. There
can be no doubt that Beaudin has studied this
culture deeply. He also has formed his face
from one heavy block; the brow and the nose
jut out sharply, the mouth is a geometric,
abstract shape. In Cubism Beaudin recognized
the possibilities of sculptural modelling and
rhythmic organization which suited him, and
his acquaintance with the primitive sculptures
of Easter Island encouraged him in this
direction. Sculpture, as well as painting, was
given an important place in his work. Beaudin,
who was born in France in 1895, was deeply
influenced by Juan Gris, from whom he learnt
to use a strict order as the basis for form.
Guided by his intellectual integrity, he always
found carefully calculated solutions. His works
do not seek to astonish, but to convince. The
ostentatiousness of the art world was alien to
him. He went his own way alone.

38b

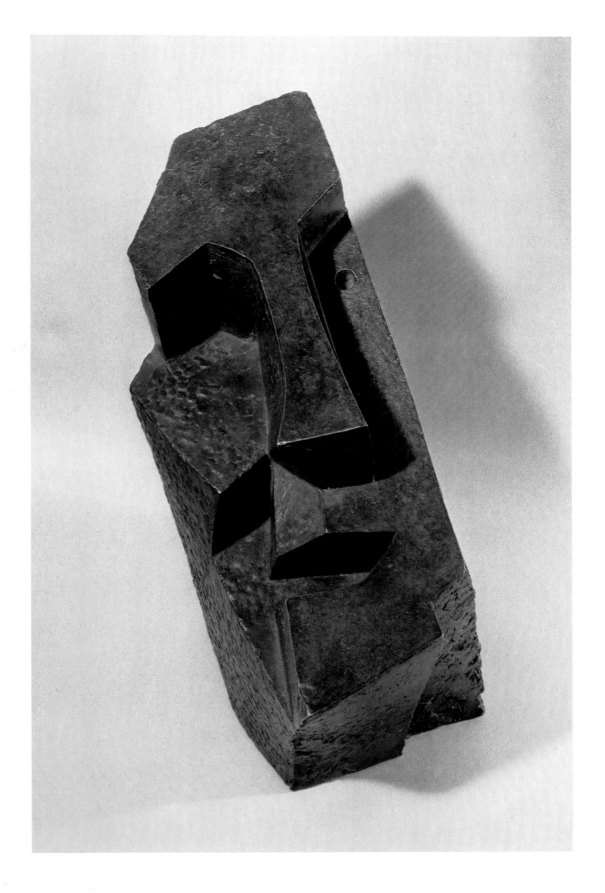

Dogon, Mali, West Africa
Standing figure, 19th century
23 cm
Charles Wentinck Collection, France
In the sphere of primitive culture, the Dogon tribe in Mali is among the most distinguished in Africa. They have kept tenaciously to their old tribal culture, although their home is not far from Timbuctoo, which is an economic centre and a spiritual focus for Islam. The blacksmith techniques often used by the Dogon people appear to have influenced the austere lines of their wood carvings. These sculptures have been preserved so well because they were kept in rock caves as burial offerings. It is not possible to give an exact date to these works, but they probably just precede the year 1800. The ancestral figures of the Dogon people are far removed from naturalistic representation. Their style is rigid and symmetric, the modelling geometric. Their absolute simplicity gives these statues a solemn monumentality. The artistic conception behind them puts them directly within the compass of the modern artistic styles which have evolved since Brancusi in 20th-century Europe.

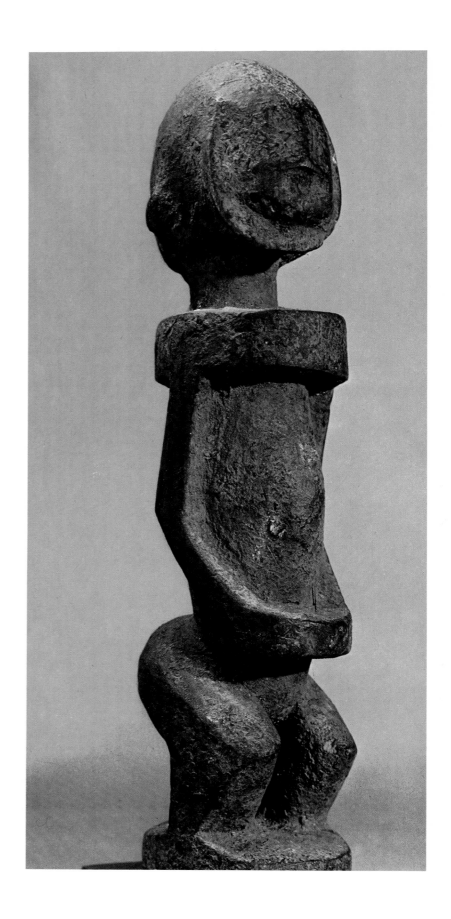

Augustin Cardenas
Étude, 1970–72
Bronze, 34 × 9 × 10 cm
Le Point Cardinal, Paris

The sculptor Cardenas, who was born in Cuba in 1927, is of Afro-American descent; herein lies his inner kinship with primitive art. What other artists have often merely appropriated may, in his case, be the expression of an unconscious essence which has not yet been influenced by his conscious mind. In any case, the structure of his study is related to the composition of the Dogon sculpture opposite. In Cardenas too, the head lacks any individuality and is present only as a geometric shape. The shoulders are reduced to a disc which corresponds to the head. Unlike the Dogon statue, the legs are not disproportionately small, but are incorporated into the architecture of the figure as a whole. We can sense a musical rhythm. Cardenas is an exception amongst the modern artists represented in this book, since, due to his ancestry, his point of contact with primitive art is more fundamental and authentic. The figure shown here is in no way exceptional: many of his sculptures are strongly and persuasively reminiscent of primitive, namely African, art. But even his art no longer belongs to a magic or religious sphere, but rather to one of formal aesthetics.

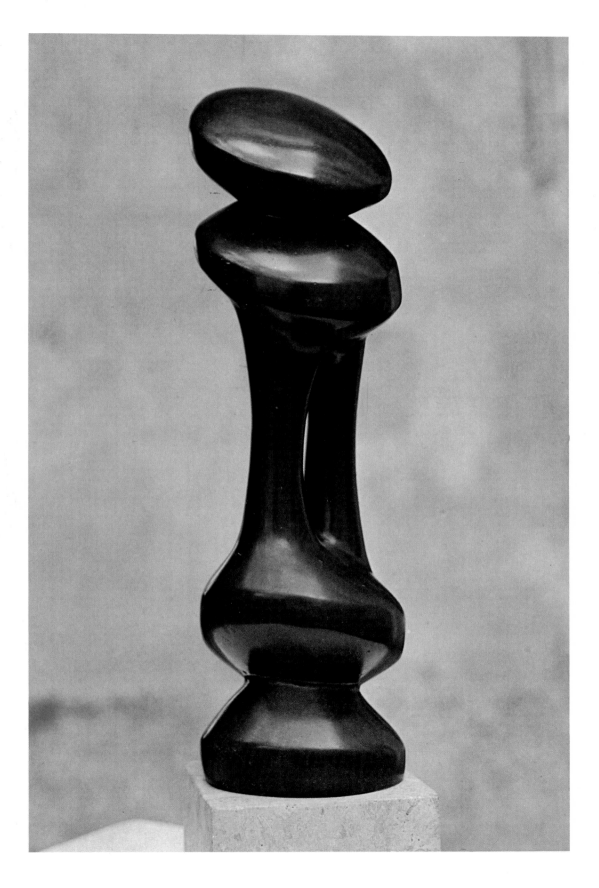

39b

Sudan

Painting on cloth, 180 × 90 cm
Musée des Arts Africains et Océaniens, Paris
Although it is difficult to determine the meaning of the shapes in this painting, we are not dealing here with a merely decorative art which is only striving after aesthetic effect. Certain motifs that occur in Dogon art, such as the Kanaga masks, can be seen here. Though heavy with meaning, the ornamentation in primitive art can influence the moderns quite independently of its original character, so that its symbolic content is not necessarily transferred as well.

Paul Klee

Witches in the Wood, 1938
Oil, paper on jute, 58 × 42 cm
Fritz Gygi Collection, Berne
In his essay on the Blaue Reiter group, to which Paul Klee belonged, Robert Goldwater concluded that, in this circle, the process of intensification and the expression of primitive elements is, as far as possible, guided by emotion. He believes that the members of the Blaue Reiter possessed a wider and more intellectual knowledge of exotic and primitive art than those who belonged to the Brücke group. For this reason, it is to be assumed that the similarity between the Sudanese cloth painting and that by Klee is by no means fortuitous. Klee, however, explained that he was far removed from primitive art; he stated that the very simple shapes of the primitives were a starting point, a beginning, while, in his case, they were the result of a conscious process of abstractpon. This may be true. Nevertheless, his creative sensibility is guided, or at least prepared, by exotic and primitive art. There is no question that Klee is imitating shapes, but his use of crooked lines and other motifs indicates a parallel development.

40a

40b